Vasily Kandinsky

1866–1944

Mikhaïl Guerman

Vasily Kandinsky
1866–1944

"…his soul strode through his life's hall of mirrors…"[1]

Herman Hesse

Text: Mikhaïl Guerman

Published in 2004 by Grange Books
an imprint of Grange Books Plc
The Grange
Kingsnorth Industrial Estate
Hoo, nr Rochester
Kent ME3 9ND

www.Grangebooks.co.uk

ISBN 1-84013-571-9

Printed in Singapore

Contents

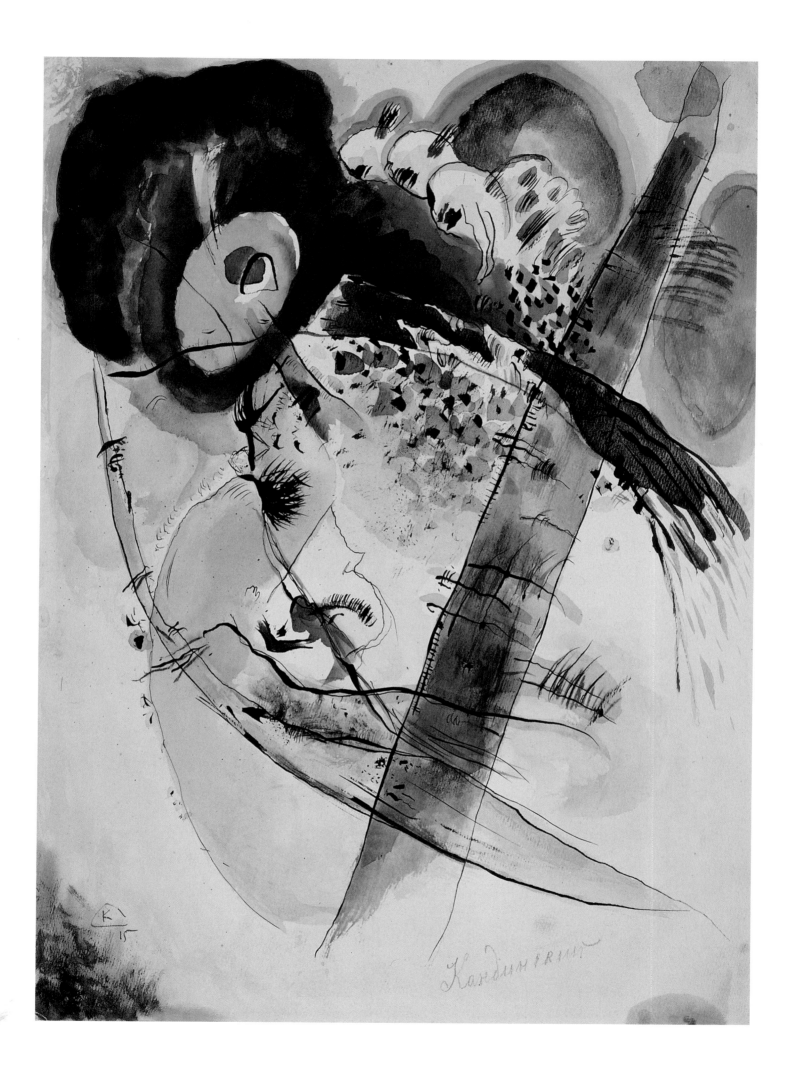

Concentration

"We are still — though in a somewhat free handwriting and a way that is upsetting enough to the bourgeois — painting the things of "reality": people, trees, country fairs, railroads, landscapes. In that respect we are still obeying a convention. The bourgeois calls those things "real" which are seen and described pretty much the same way by everybody, or at least by many people."

–Hermann Hesse, *Klingsor's Last Summer*

Not long ago it seemed that this century had not only begun with Kandinsky, but ended with him as well.[1] But no matter how often his name is cited by the zealots of new and fashionable interpretations, the artist has passed into history and belongs to the past and to the future to a greater degree, perhaps, than to the present. So much has been written and said about Kandinsky. His works, including his theoretical ones, are so well-known that this abundance of knowledge and commonplace opinions often hinders our seeing the artist in his individuality, in his real — not mythologized — significance. With a fresh gaze. From the threshold of the third millennium.

Weary of arch postmodernist games, the experienced and serious viewer today seeks in Kandinsky that which no one had seen in him earlier — and had not attempted to see: a buttress in an unstable world of artistic phantoms and fashionable shams. What just less than a hundred years ago was born as a bold revelation has now passed over into the category of eternal values. Among the titans of modernist art, Kandinsky was a patriarch. Matisse was born in 1869; Proust, in 1871; Malevich, in 1878; Klee, in 1879; Picasso, in 1881; Kafka, in 1883; Chagall, in 1887. Kandinsky himself was born in 1866, a year that also

Exotic Birds,
Tretyakow Gallery, Moscow.

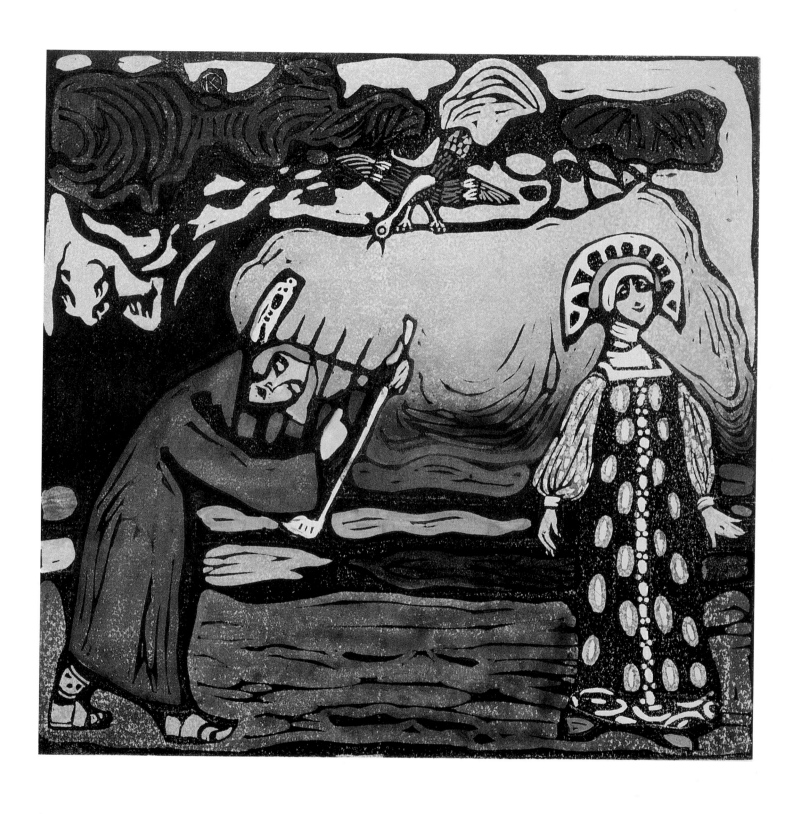

Gouspiar,
Tretyakow Gallery, Moscow.

Prayer.

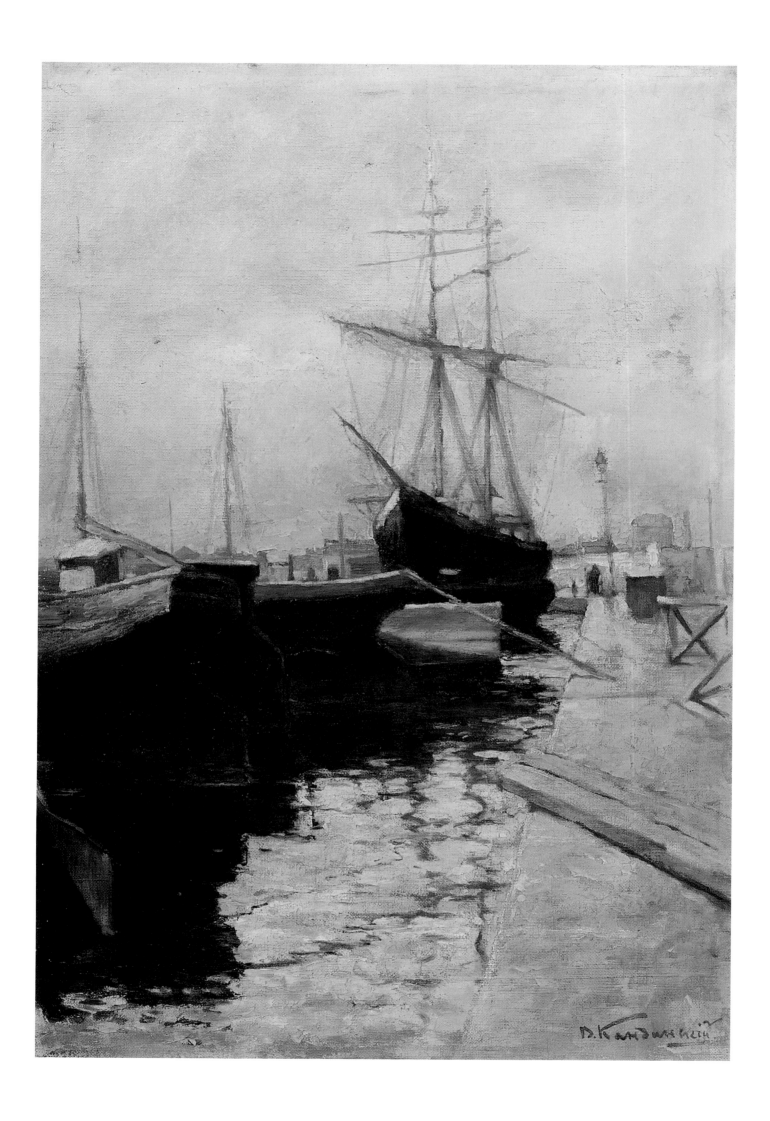

10

witnessed the birth of Romain Rolland and the publication of Dostoevsky's *Crime and Punishment. Anna Karenina* had yet to be written and no one had yet pronounced the term "Impressionism." Kandinsky, in a word, was born in "the very depths" of the nineteenth century. Kandinsky was twenty when the last exhibition of the Impressionists opened; he was thirty-four when Ambroise Vollard held the young Picasso's first one-man show in his gallery. At the turn of the century Kandinsky was only just beginning to become a professional, his name was still unknown — and he did not yet know himself.

Kandinsky's intellectualism and that of his art have constantly been noted by scholars and essayists. This situation is not typical: the young paladins of the avant-garde attracted their adepts not so much with knowledge and logic as with the radicalism and the spiritedness of their opinions; and, more often, with a meaningful incomprehensibility interspersed with brilliant revelations. The destiny of a master who linked his art with Russia, Germany and France; his work as a teacher in the celebrated Bauhaus; his prose, verse and theoretical writings; his unbending and determined path towards individuality — all of these things have made Kandinsky more than just another of the great artists of the twentieth century. In the culture of our age he has occupied a quite exceptional place: the place of an artist alien to vanity and with a desire to shock the viewer; the place of a master inclined to constant and concentrated meditation, to unswerving movement towards a synthesis of the arts, to the quest for more perfect, ascetic and strict formal systems. Moreover, Kandinsky's art does not reflect (or, if one may say so, is not burdened by) the fate of other Russian avant-garde masters. He left Russia well before the semi-official Soviet esthetic turned its back on modernist art. He himself chose where he would live and how he would work. He was forced neither to struggle with fate nor to enter into conspiracy with it. His "struggles" took place "with himself" (Boris Pasternak). The persecutions to which "leftist" artists in Russia were subjected left him untouched and did not complicate his life. Neither, however, was he was awarded a crown of thorns or the glory of a martyr, like the lot of those famous avant-garde artists who remained in Russia. His reputation is in no way obliged to fate —

The Port of Odessa, late 1890s.
Oil on canvas, 65 x 45 cm,
Tretyakow Gallery, Moscow.

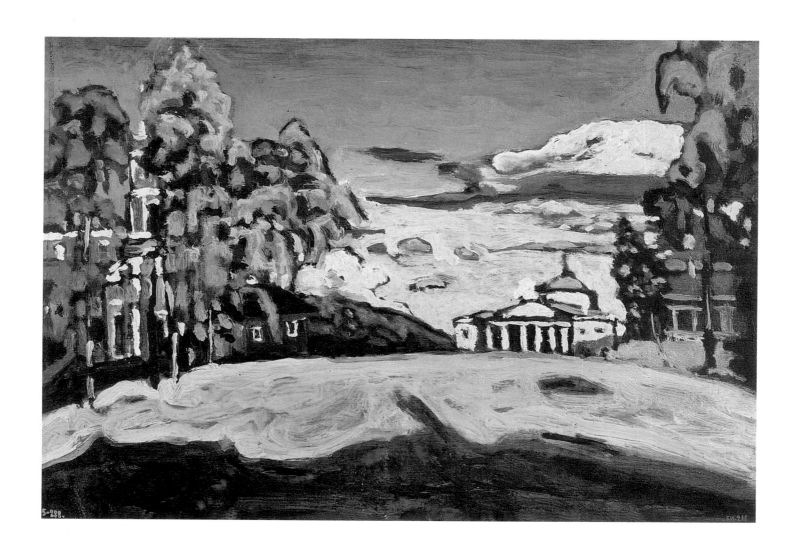

Landscape Near Achtyrka,
Tretyakow Gallery, Moscow.

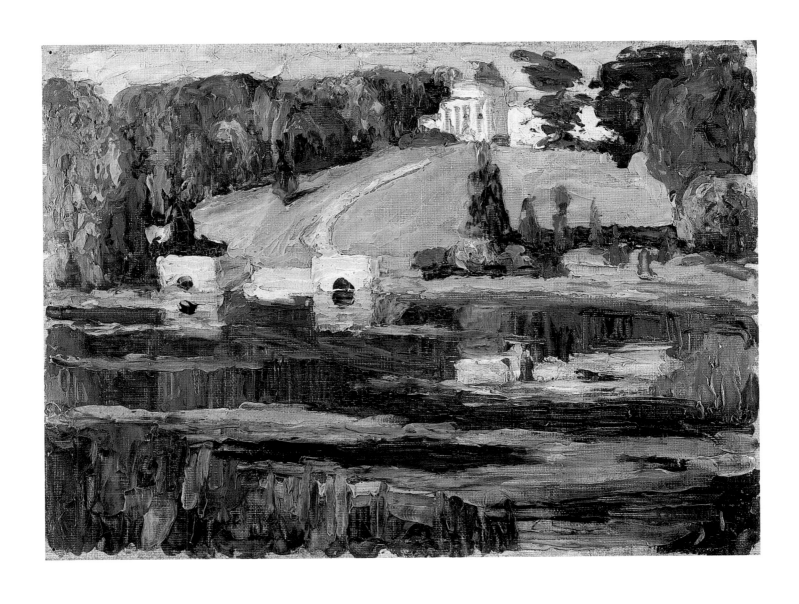

Achtyrka. Autumn, sketch, 1901.
Oil on canvasboard, 23.7 x 32.7 cm,
Städtische Galerie im Lenbachhaus,
Munich.

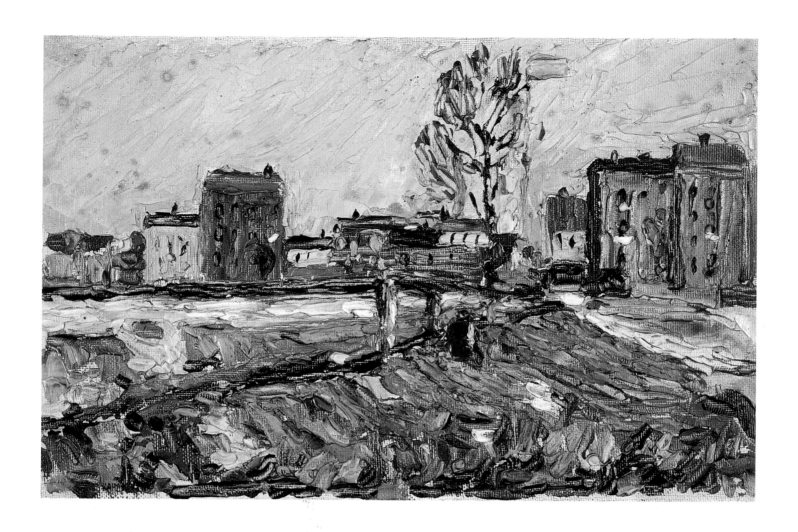

Munich. Schwabing, 1901.
Oil on cardboard, 17 x 26.3 cm,
Tretyakow Gallery, Moscow.

Red Church, 1901.
Russian Museum, St Petersburg.

only to art itself. The culture of the past was for him precious and intelligible: he was not concerned with the smashing of idols. Creating the new occupied him entirely. He aspired neither to iconoclasm nor to scandalous behavior. It could hardly be said that his work lacked daring, but this was a daring saturated with thought, a polite daring argued with art of the highest quality.

Educated in the European manner, a man of letters, a professional musician, and an artist much more inclined to reflection and to strict (but not altogether unromantic) logic than to loud declarations, Kandinsky preserved the dignity of a thinker, refusing to dissipate this dignity in petty quarrels within the artistic world. It has been said many times and said justly that the roots not only of Kandinsky's art, but of his attitude to life in general, lay in Russia and Germany. It is of the essence here that Kandinsky identified Russia with Moscow. As opposed to the majority of those of his famous compatriots who shared his views (if such existed in the full sense of the phrase),

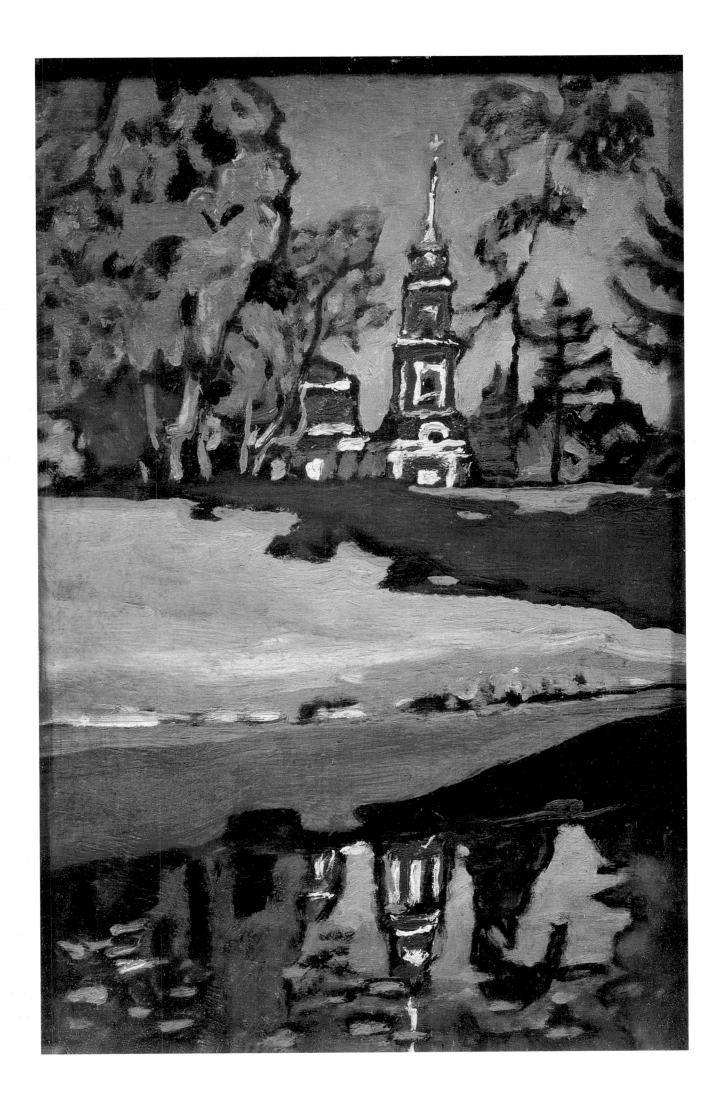

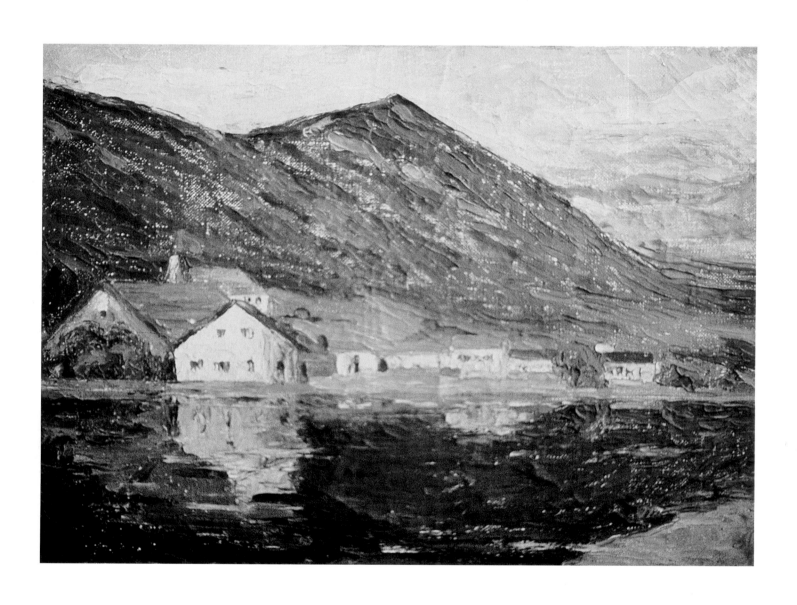

Mountain Lake, 1899.
Oil on canvas, 50 x 70,
Manukhina Collection, Moscow..

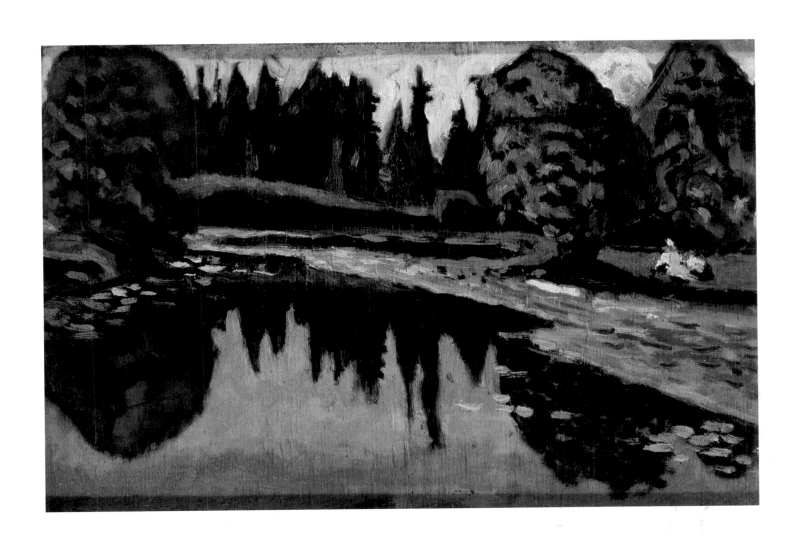

Summer River

Kandinsky had practically no connections with the culture of St. Petersburg. Kandinsky escaped that purgatory between East and West, unable to accept its cool refinements and traditional *passéisme*. Petersburg's dangerous and seductive mirages left his mind unclouded and his heart uninspired. In intellectual terms, especially as concerns philosophy, Kandinsky was oriented towards the German traditions.[2] But notwithstanding his interest in the past, he did not become its hostage, seeing in its wisdom the foundations for understanding and building the future. Kandinsky painted his earliest works when already a mature man. Kandinsky was in the zenith of his fourth decade. A time in life when it is not easy to feel oneself a beginner. His first known canvasses date from the turn of the century: 1899 — *Mountain Lake* (M. G. Manukhina collection, Moscow); 1901 — *Munich. Schwabing* (Tretyakov Gallery); *Akhtyrka. Autumn* (Städtische Galerie im Lenbachhaus, Munich); c. 1902 — *Kochel* (Tretyakov Gallery). The painting *Odessa — Port* (late 1890s, Tretyakov Gallery), which opened the celebrated 1989 Kandinsky retrospective, already concealed a certain magic.[3] While that exposition was still being prepared, amidst the abstract works or alongside the pictorial insights of Murnau, this painting seemed nearly dilettantish and almost Wanderesque. But next to it, any Wanderer landscape seemed passive and rooted in an impression taken from life. Of course, looking for the traits of future genius in the work of a neophyte is a very sly pursuit: it is easy to find what one wants to find instead of what is there. But, nevertheless, its elastically outlined, dark and radiant patches are much too independent of the object world, there is too much hidden tension in them which is unconnected with any real motif. The much too powerful drawing appears purely decorative alongside a fairly naive and traditional understanding of objective form.

There is no doubt that this strict and powerful intellect had an emotional existence as well. Certain passages in Kandinsky's writings recall the opinions of Marc Chagall, an artist altogether bereft of logic and education. The blue signboard hanging outside Yuri Pen's school (Pen was Chagall's teacher in Vitebsk), which made such a powerful impression on the future artist, is a relative of the blue

Farewell (large version), 1903.
Oil on panel, (two blocks),
31.2 x 31.2 cm,
Tretyakow Gallery, Moscow.

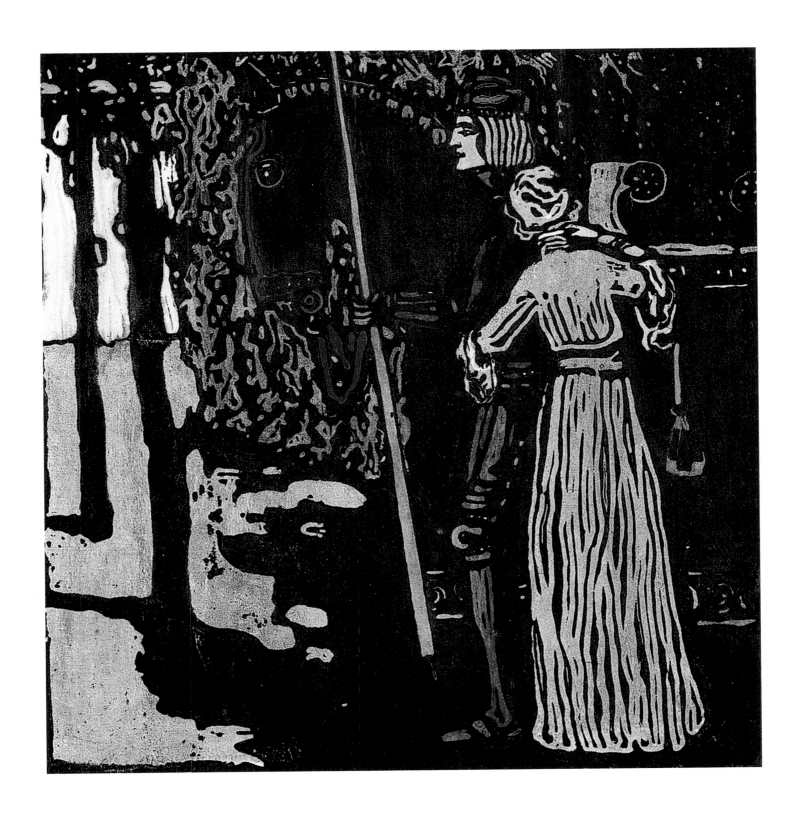

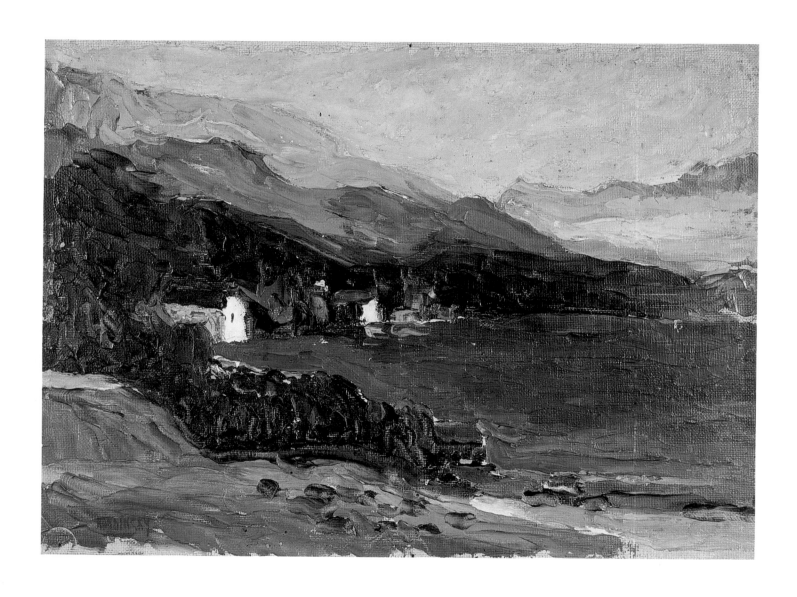

*Kochel (The Lake and the Hotel Grauer
Bär)*, ca 1902.
Oil on cardboard, 23.8 x 32.9 cm,
Tretyakow Gallery, Moscow.

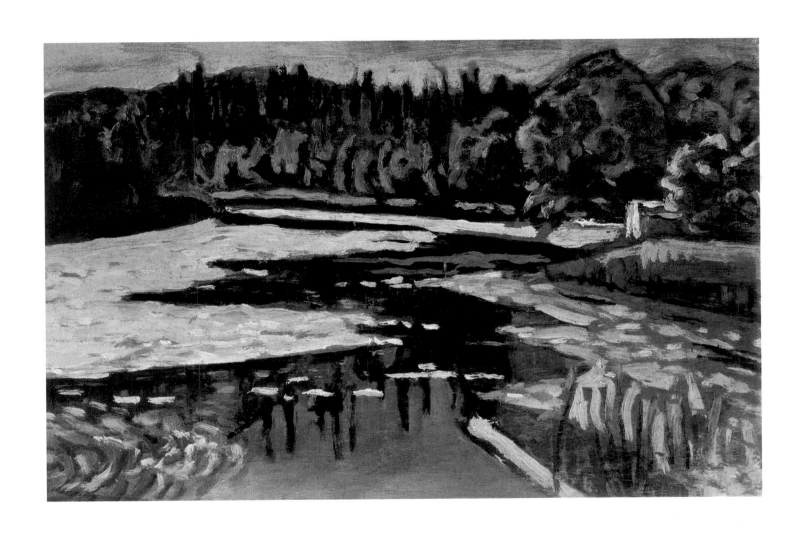

Autumn River,
Russian Museum, St Petersburg.

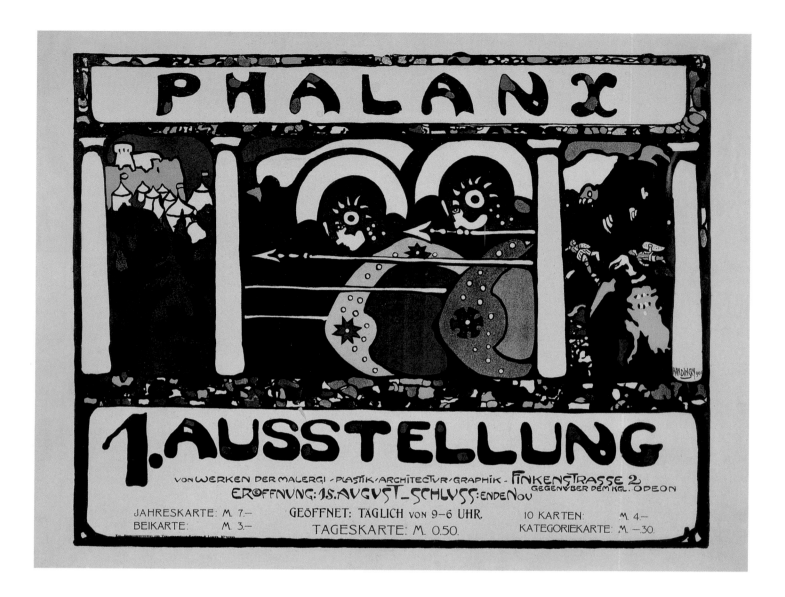

Poster for the first "Phalanx" Art School exhibition, 1901.
Color lithograph (after Kandinsky's drawing), 47.3 x 60.3 cm,
Municipal Gallery of Lenbachhaus, Munich.

tramcar, the blue air and singing, bright-yellow mailboxes that delighted the thirty-year-old Kandinsky in Munich.[4] And later, in his famous *Klänge*, the phrase "Unten stach der kleine blaue grüne See die Augen" ("Down below the little blue green lake caught his eye")[5] shows that these kinds of visual revelations were congenial to Kandinsky.

There is no doubt that, for a beginning student, Kandinsky was much too mature. Generally speaking, he had already gained a lot of knowledge as a result of his extensive reading and thinking. He had been to Paris and Italy, even giving Impressionism its due in his earliest works (we have already had occasion to mention this). However, it was only in Germany that he aspired to study. It is obvious that in his preference for Munich over Paris, Kandinsky had been thinking more about schools than about artistic milieus. In any

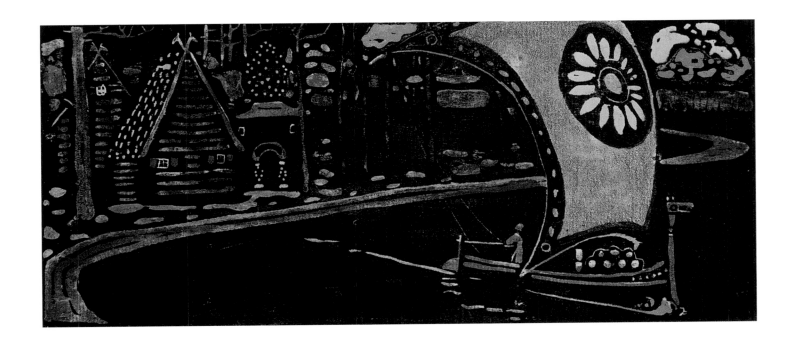

case, when Kandinsky had only just enrolled in the private school of Anton Azbè, renowned for its unswerving professionalism, Igor Grabar wrote (apparently, with good reason) that Kandinsky "ha[d] no ability whatsoever" and that "he ha[d] a very foggy notion of decadence."[6] It may seem paradoxical, but, given his enormous talent and serious education, Kandinsky's "inability" and, moreover, his not being a decadent, allowed him to be independent of fashionable trends of the prevalent tradition. In other words, he was able to preserve the highest degree of artistic freedom.

The study of drawing at the Azbè School did not bring Kandinsky much. He never developed a taste for academic studies, the nuts and bolts of the trade which attract so many artists. But, as if following the well-known Chinese dictum, "Once you have understood the rules, you will succeed in changing them," he tried to learn the rudiments before setting about to "realiz[e] [his] own feelings" (Cézanne). It is hard for us to understand what attracted Kandinsky to Franz Stuck after Azbè. Perhaps it was the fact that Stuck taught at the Academy of Arts, not in a private school, that he was revered as the best draughtsman in Germany, or that he was more famous than other artists. Whatever the case, his work could hardly have served Kandinsky as a standard of good taste and deep originality. We are forced to suppose that it was merely Stuck's teaching method which interested Kandinsky. The gloomy and pretentious pathos of

Veil of Gold, 1903.
Tretyakow Gallery, Moscow.

23

Holland, Beach Chairs, 1904.
Oil on canvas, 24 x 32.8 cm,
Municipal Gallery of Lenbachhaus,
Munich.

Spring,
Russian Museum, St Petersburg.

Church in Murnau I, 1910.
Oil and watercolour on cardboard,
Municipal Gallery of Lenbachhaus,
Munich.

Church in Murnau, 1908-1909.
Oil and tempera on cardboard,
Museum of Fine Arts, Omsk.

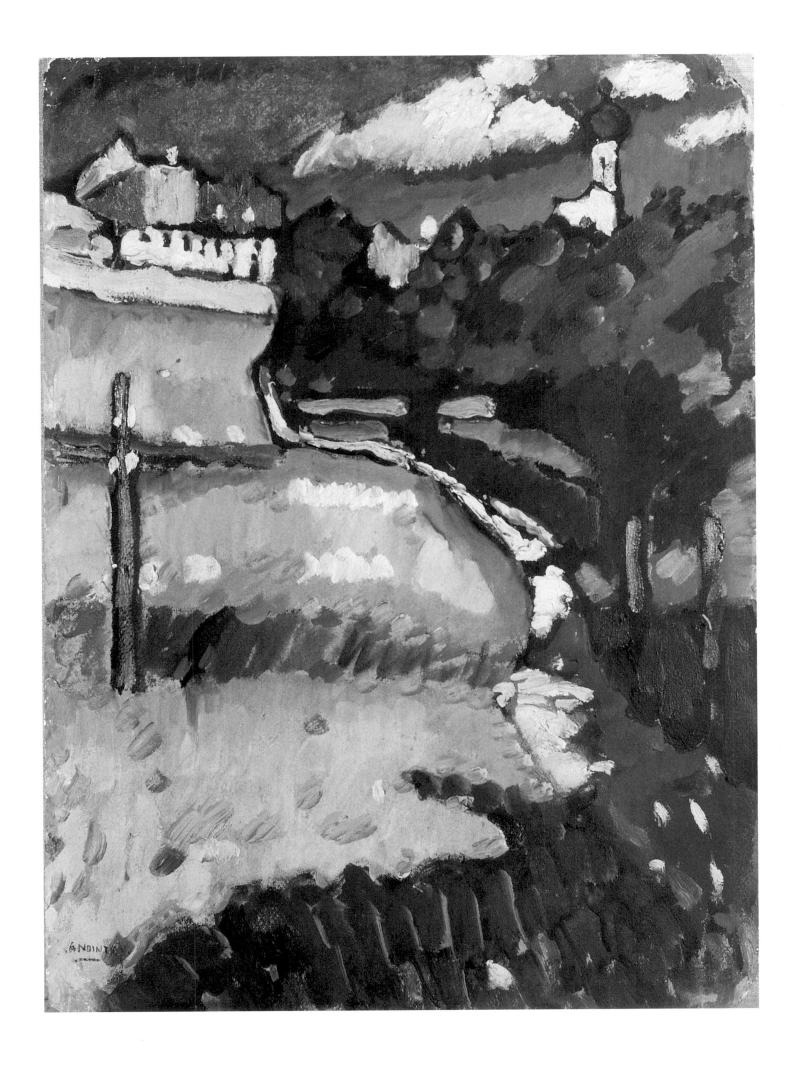

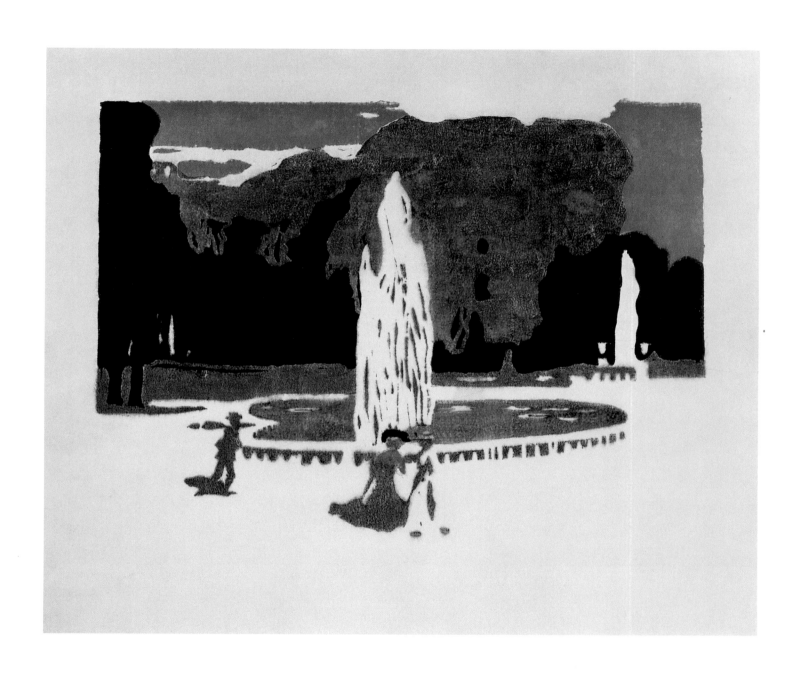

Stuck's works, the total absence in them of "the substance of art" (Merezhkovsky), his traditionally illusory depiction of pompous, "terrifying" heroes — all this was more likely to interest lovers of salon painting.[7]

Even though Kandinsky succeeded in being admitted to Stuck's studio in the Munich Academy only after his second attempt, he would leave it a little more than a year later. Kandinsky was only just beginning as an artist when he exhibited his painting *Evening* at the seventh exhibition of the Moscow Association of Artists (Kandinsky's participation was supported by that exhibition's hero, Viktor Borisov-Musatov). If alongside Borisov-Musatov's subtle and meaningful canvasses Kandinsky's work did not seem out of place, then how are we to imagine its sharing the same space with the works of Polenov or Bialinitsky-Birulia? At that time (February 1900), in the halls of the Stroganov Academy — a fifteen-minutes' walk from the Historical Museum, in which Kandinsky's painting was hanging — people crowded before the canvasses of his renowned teacher, Franz Stuck, paintings which undoubtedly were the center of attention at the General German Exhibition. Kandinsky's early works drew fairly sharp criticism in Moscow. Not meeting with particular approval anywhere and not yet feeling himself to be a professional, Kandinsky, despite everything, was imperceptibly and quite naturally transformed from an apprentice into a master. He was right when he sensed the incomprehension of both Russian and German criticism: the former detected a pernicious "Munich influence;" the latter, "Byzantine influences."[8] Stranger to all, he himself was capable of perceiving everything. Kandinsky might have spoken the lines Valery Bryusov wrote in 1899:

And strangely I came to love the gloom of contradictions,
And hungrily I went in search of the fatal knots,
All dreams are sweet to me, all tongues are precious,
To all the gods I dedicate my verse…

What for the twenty-seven-year-old poet had been a coquettish declaration affirming the all-accepting hedonism of a pagan and decadent was for Kandinsky, however, a testament to a sincere and

The Park of Saint Cloud,
Color Xylograph, 18.9 x 23.9 cm,
Private Collection, Moscow.

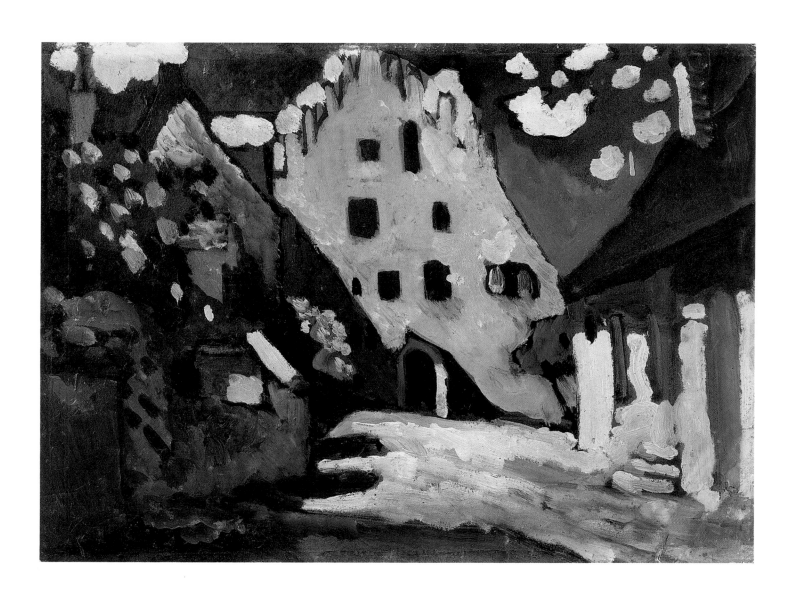

Street in Murnau, 1908.
Oil on cardboard, 33 x 44.3 cm,
Tretyakow Gallery, Moscow.

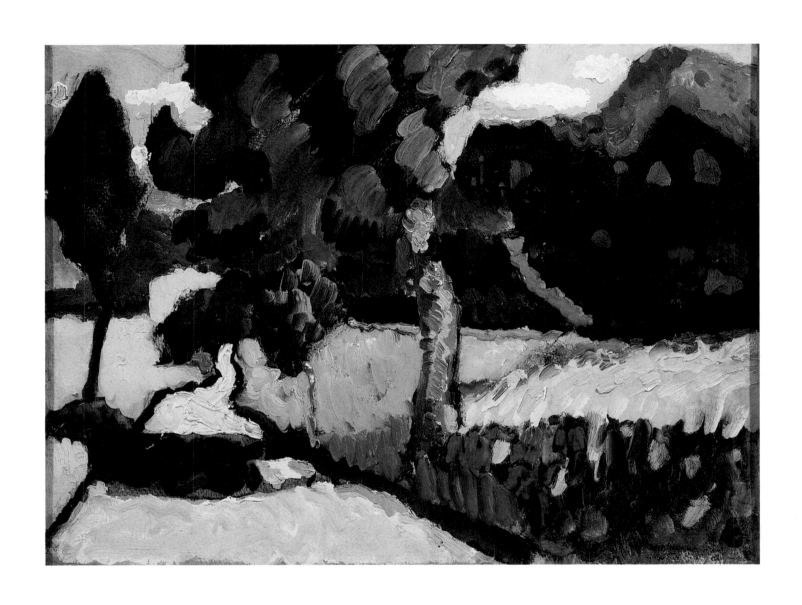

Summer Landscape, 1909.
Oil on cardboard, 34 x 45 cm,
Russian Museum, St Petersburg.

intense openness. It is just such openness which alone can serve as the foundation for genuine self-sufficiency. Critics speak with some basis of the "polystylism" of the early Kandinsky.[9] The qualities of salon Impressionism, a hint of the dry rhythms of modernism (German Jugendstil), a heavy "demiurgic stroke" reminiscent of Cézanne (true, quite remotely), the occasionally significant echoes of Symbolism — all of these things (and much else) can be found in the artist's early works. These qualities were characteristic of many young artists of the period. But from the outset Kandinsky painted like a mature artist, albeit an unskilled one. He tried his hand at a number of styles, on a number of different paths. But it was precisely his own hand that he tried, not that of anyone else. As early as the turn of the century a critical mass of active information (visual and philosophical) had accumulated in Kandinsky's artistic consciousness. He was far from being interested in everything, but "all tongues" were, in fact, "known" to him. In his own development, Kandinsky passed through the entire history of culture, encompassing it within one destiny. His art was no stranger to the naive tale and to the highest flights of abstraction and decorative refinement. He came to his first significant works with a consciousness that was truly saturated, on the point of bursting. The new Russian philosophy, the art of the icon, the genre of historical painting, modernism, the lucid strength of Impressionism, an understanding of the power of Matisse's color and Picasso's form and, most of all, his own insistent and intense meditations all informed a staggering readiness for self-realization. But the range of his stylistic experiments at the turn of the century was excessive: it suffices to compare the nervous and eclectic (though subordinated to modernist rhythms) color woodcut *Golden Sail* (1903, Tretyakov Gallery) with the "taciturn," severe and meaningful painting *Beach Baskets in Holland* (1904, Städtische Galerie in Lenbachhaus, Munich). An openness "to all tongues" enabled Kandinsky to enrich himself without submitting to the influence of others. A knowledge of the art of Germany, France and Holland in the first decades of this century might have enslaved anyone else, but it only enhanced Kandinsky and inclined him towards contemplation. Like Ibsen's heroes Brand and Peer Gynt, Kandinsky was seeking only himself.[10] Not yet capable of expressing the creative passion overpowering him, Kandinsky used life studies as a means of "fishing"

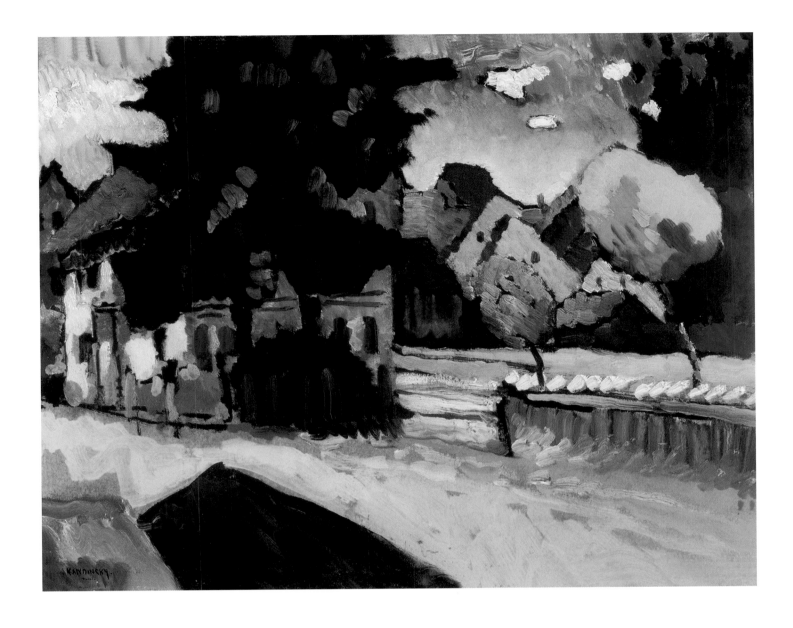

for motifs which might become crucial elements in the realization of his as yet unclear aspirations. Thus, while still not himself a professional, he mustered the courage to found a new artists' organization in Munich, the Phalanx group. Soon afterwards, Kandinsky began teaching at an art school opened by the group. He did not teach the secrets of the higher artistic disciplines, but the fundamentals of the profession: drawing and painting. His pursuit of teaching was not the product of the benighted bravery of a narcissistic genius with no purpose in life, but rather was born of the desire to find himself in dialogue — if not with others of like mind, then with people who could be fascinated by the things which had fascinated him.

One very important aspect of creative work in the twentieth century — interpretation during the process of creation — apparently had a

Murnau. Landscape with Green House, sketch, 1908.
Oil on cardcoard, 33 x 44 cm, Hermitage, St Petersburg.

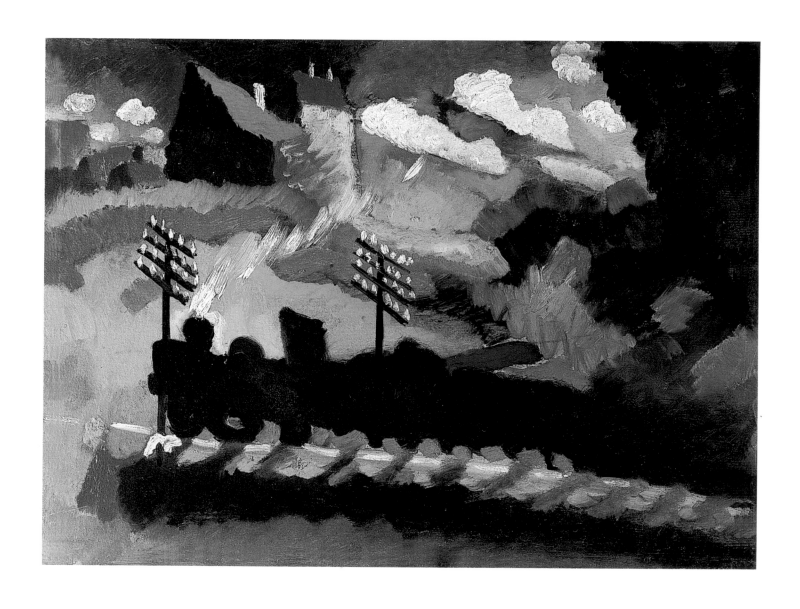

Landscape Near Murnau with Locomotive,
1909.
Oil on cardboard, 26 x 49 cm,
Municipal Gallery of Lenbachhaus,
Munich.

quite particular significance for Kandinsky. He worked together with
his students in their search for truth. But desire, courage and talent were
not enough. Kandinsky had to possess the vigor, conviction and
authority to make others see him as a true leader. For at this point in his
career he had not yet painted anything which might have been called, if
not a twentieth-century sensation, then at least a landmark designating
the emergence of a fundamentally new trend in art. Apparently there
was something in him which inspired trust. And what is more, it was
Kandinsky's extraordinary pedagogical abilities that contemporaries
noted.[11] The Phalanx's authority became so great that such masters as
Paul Signac and Felix Vallotton participated in the group's exhibitions.
The works of Toulouse-Lautrec (who had died in 1901) were presented
in Phalanx exhibitions as well. In the space of three years, Phalanx held
twelve exhibitions, an unusually high number. Towards the end of this
period, the German press began to speak seriously of Kandinsky.

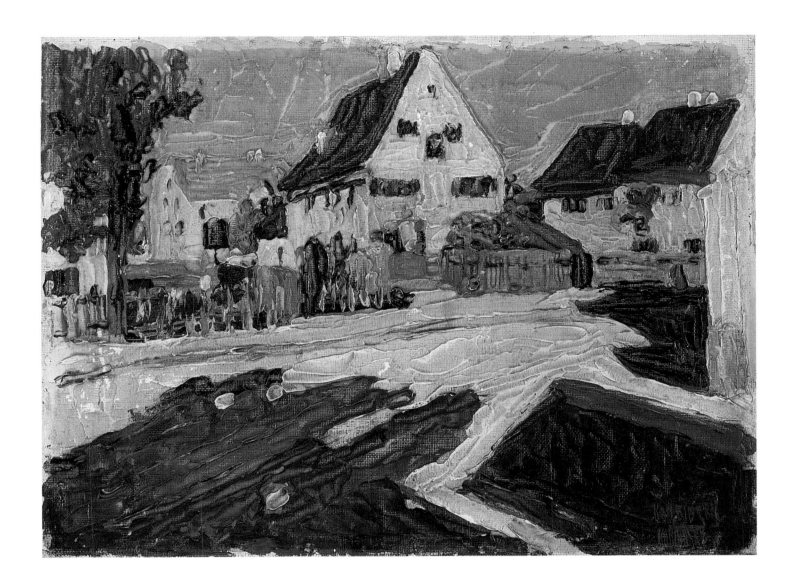

Giving his work the highest estimation, they cautiously and deferentially called his talent "original." He was invited to teach at the Kunstgewerbeschule in Düsseldorf. He participated in the 1902 exhibition of the Berlin Secession and, later, in the Salon d'Automne (he became a jury member in 1905) and Salon des Indépendants exhibitions in Paris. One could say that Kandinsky had acquired a reputation more elevated than stable and well-defined. One of the more important events determining Kandinsky's place in the artistic process of that time was his participation in an exhibition of the Dresden group Die Brücke (the Bridge), the first association of the Expressionists. The paintings and prints of these years are executed in a spirit of unrealized energy. They are capable of delighting, disappointing or exciting curiosity. There is much in them that is attractive, talented and fascinating. But in these works the real Vasily Kandinsky is absent, or nearly so.

Street in Sun of Fall, Oil on canvas.

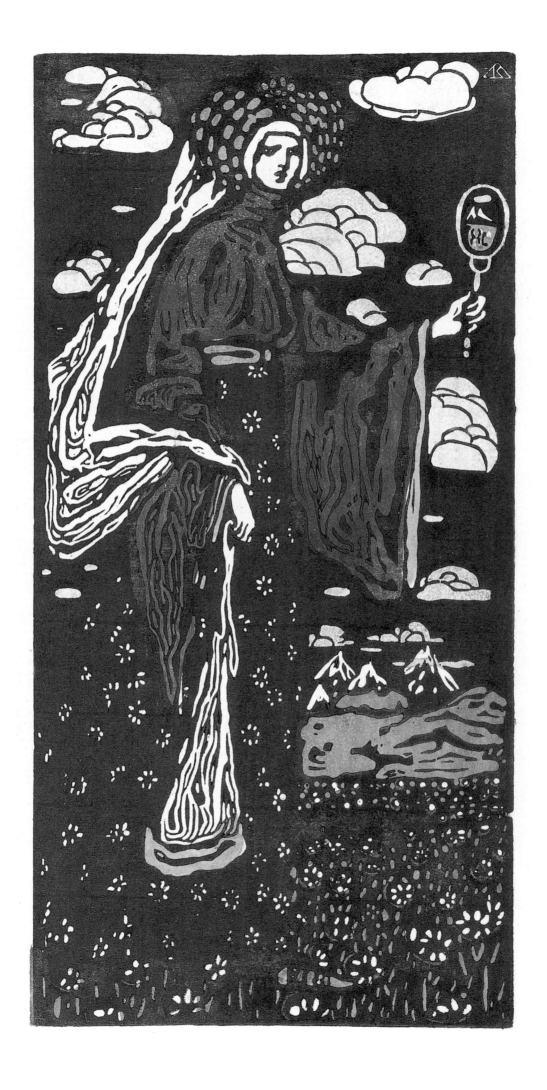

36

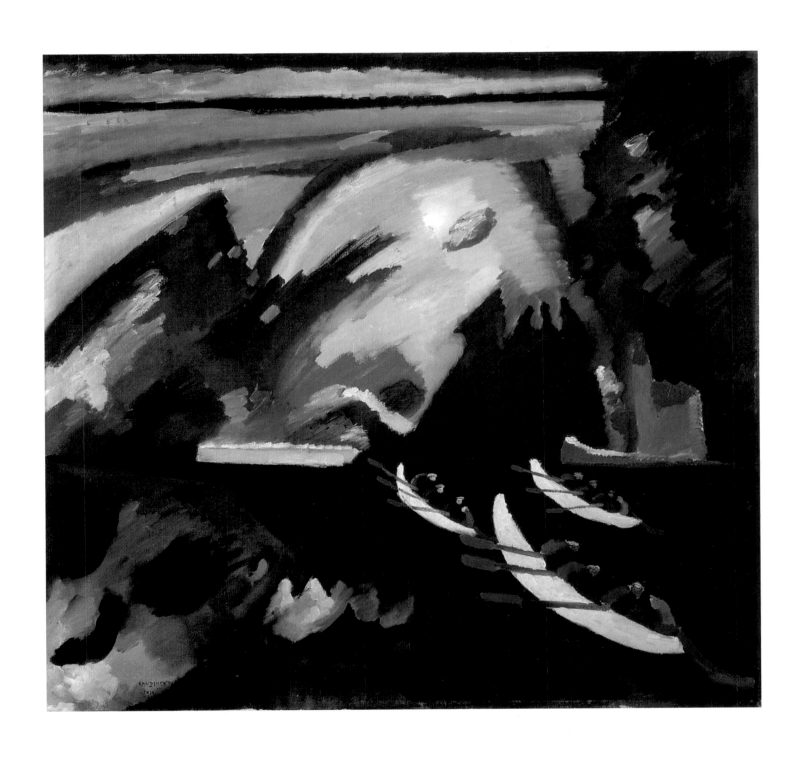

Mirror, 1907.
Municipal Gallery of Lenbachhaus,
Munich.

Boat Trip, 1910.
Oil on canvas, 98 x 105 cm,
Tretyakow Gallery, Moscow.

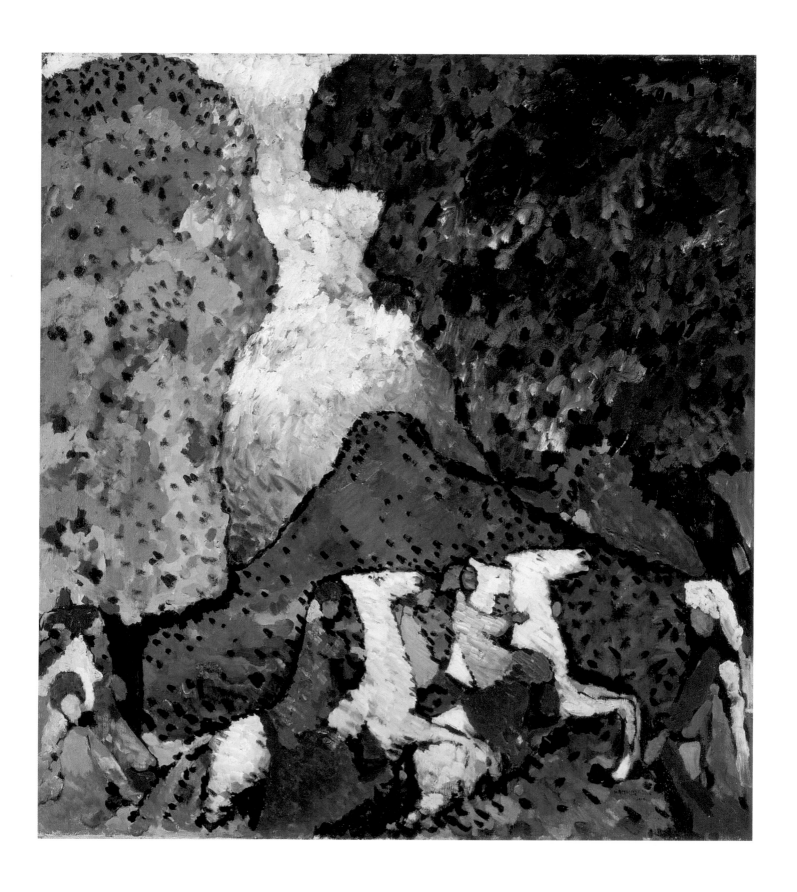

The Miracle at Murnau

"It seems to me I've only begun to really paint this year."

–Hermann Hesse, *Klingsor's Last Summer*

Usually the first buds of something new ripen in an artist's soul long before this new thing becomes historical reality. History tells us, however, of certain moments of culmination, "shining hours," when searches that have quietly smoldered for years suddenly flare up like comets.

The middle of this century's first decade was saturated with such events: the first exhibit of the Fauves at the 1905 Salon d'Automne; the founding in the summer of that same year of Die Brücke; and finally, the stormy and shocking manifesto not only of Cubism, but of a wholly new vision — Picasso's *Les Demoiselles d'Avignon* (1907). The work that Kandinsky produced in Murnau at the end of this decade was another such "moment of truth." There are few moments (if there are any at all) in the history of art as dramatic and magnificent as Kandinsky's coming into his own in Murnau. As a rule, an artist arrives at the creation of an individual style or a new direction in several stages. Even Picasso's development was relatively gradual. Kandinsky's evolution was marked, of course, by such gradualness as well, but it is unlikely that any other artist has experienced the same bright explosion or the same release of energy after years of agonizing artistic inarticulateness. The object world was for Kandinsky both a source of artistic ideas and a fetter: he was not striving to create a new language for the sake of itself. Like Cézanne or Hemingway (who studied clarity of self-expression from the former's paintings), Kandinsky wanted only to become himself, without yet knowing what it was he wanted to become. Only one thing was obvious: his aspiration to an absolute, all-conquering individuality and to a synthesis, perhaps even a syncretism, of the arts. He

The Blue Mountain, 1908-1909.
Oil on canvas, 106 x 96.6 cm,
Guggenheim Museum, New York.

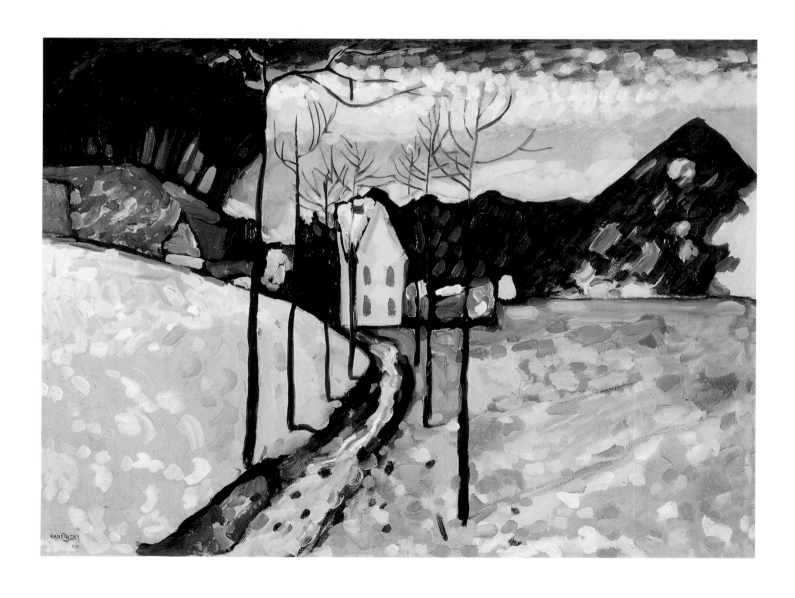

Winter Landscape I, 1909.
Oil on cardboard, 75.5 X 97.5 cm,
Hermitage, St Petersburg.

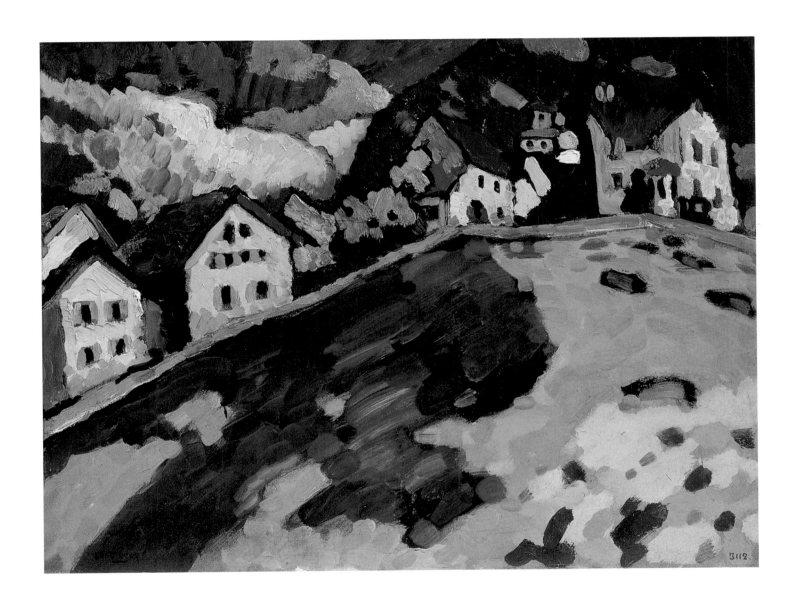

Summer Landscape.

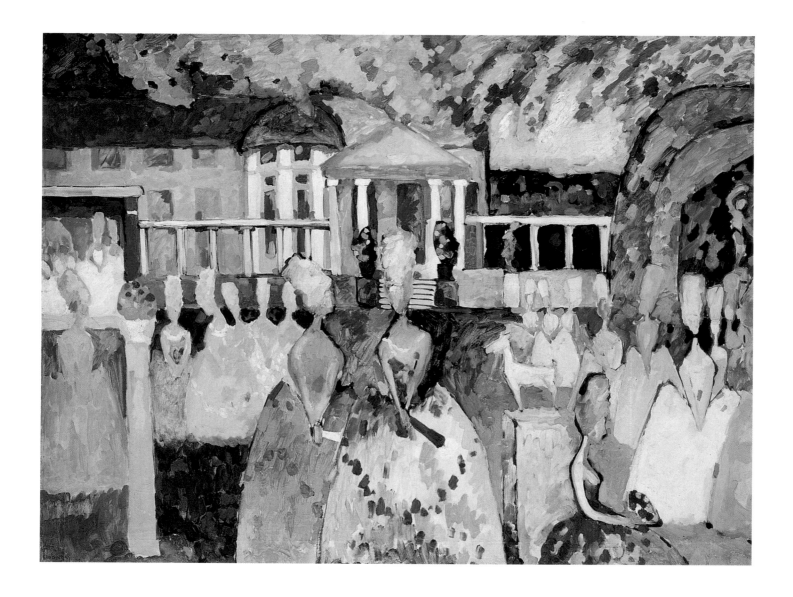

Ladies in Crinolines, 1909.
Oil on canvas, 96.3 x 128.5 cm,
Tretyakow Gallery, Moscow.

discussed music and poetry no less often than he did painting. But it was precisely in the graphic arts where the breakthrough took place.

The often-cited passage from Kandinsky's writings where he speaks of landscapes which agitated him "like the enemy before a battle" and conquered him is indeed very telling.[12] While nature held sway, it attracted the artist with the undisclosed secret of its harmonious dramas, dramas camouflaged by reality. Nature's charm enthralled Kandinsky, thus hindering him from passing "through it." When we look into a man's face, we seek out his candid gaze in order to glimpse something completely inward and secret, in order to glimpse the disturbing, individual and not at all corporeal truth. Just as when we seek this terrifying and magnificent truth with an absoluteness to which we alone are privy, so this mature artist (already a genius, but still far from being a master) sought "the gaze of reality."

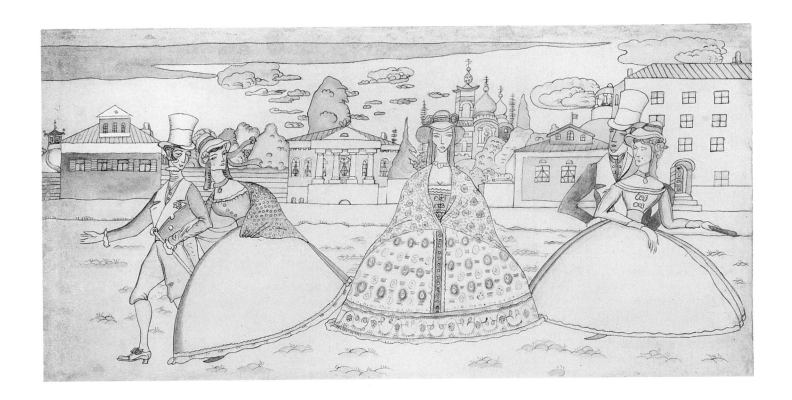

The word *zazerkalye* ("the land behind the looking glass" — the title of the Russian translation of Carroll's *Through the Looking Glass*) has taken root in Russian translation tradition. It is a wonderful find, a new metaphor for our twentieth-century literature. This notwithstanding, however, the title of Lewis Carroll's book in the original English had been forgotten. While not as splendid, this title has a somewhat different sense: through the looking glass.

As an important phenomenon in art, as an "instrument of the metaphor of plasticity," the mirror has been used by artists from time immemorial:[13] the mysterious mirrors of the old Dutch masters, concentrating the great within the small or serving as incarnations of the Madonna; the mirror of Velázquez's *Venus*; the royal couple in Goya's painting with its stunning "effect of self-contemplation;" the mirror of Marc Chagall; Dostoevsky's doubles;[14] and Kandinsky's own linoleum cut *Mirror* (1907, Städtische Galerie in Lenbachhaus, Munich), its strange, powerful sketchiness enclosed within an affected rhythmics in the Jugendstil manner.

For the twentieth-century artist, reality likewise becomes that cunning mirror whose amalgam does not allow him to penetrate into "the land behind the looking glass," the only thing that he seeks. Other artists simply went ahead and created a new reality: between

Ladies in Crinolines,
Tretyakow Gallery, Moscow.

43

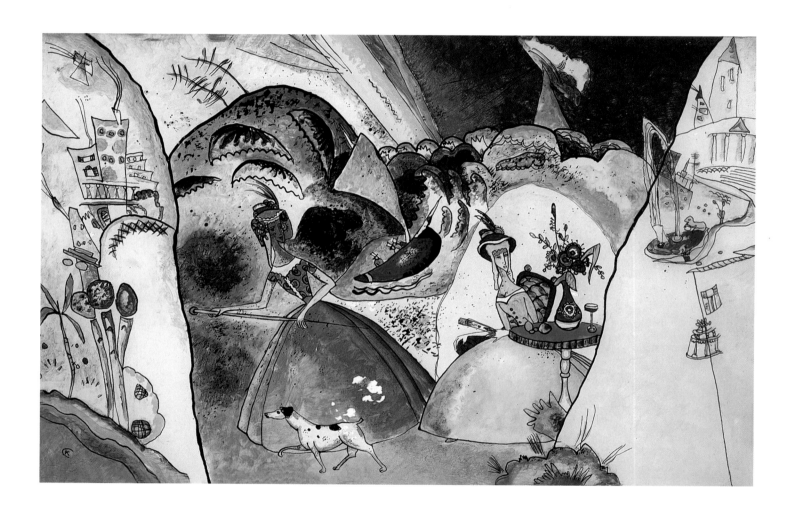

Ladies in Crinolines, about 1918.

Woman in a Gold Dress,
Oil on foil, glass, 17.3 x 16.1 cm,
Tretyakow Gallery, Moscow.

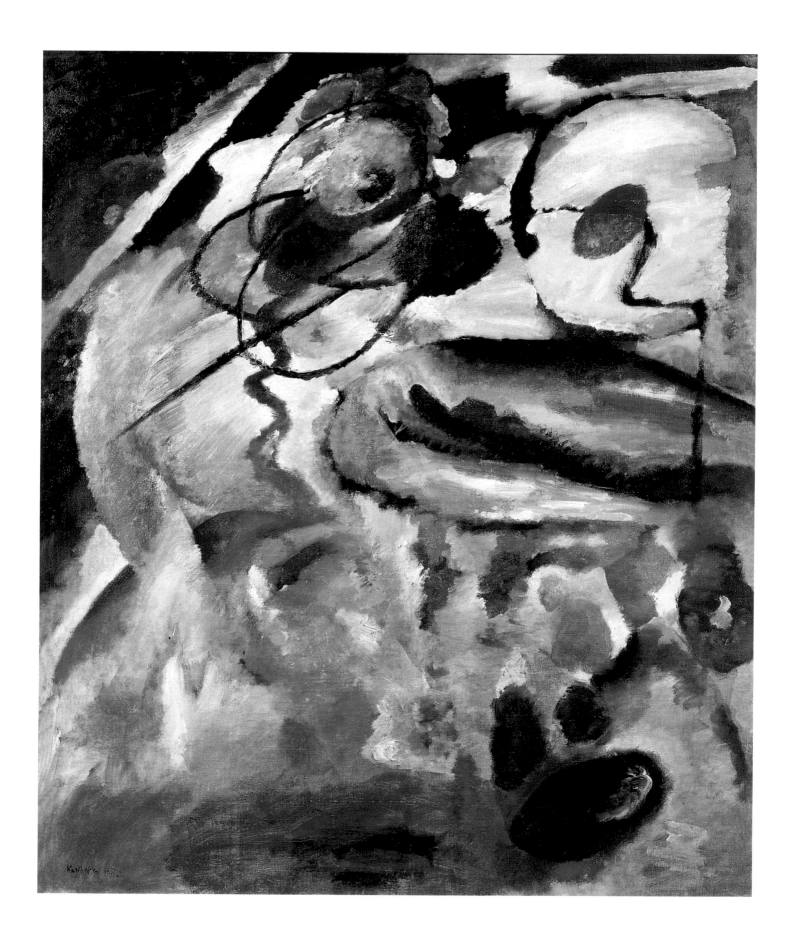

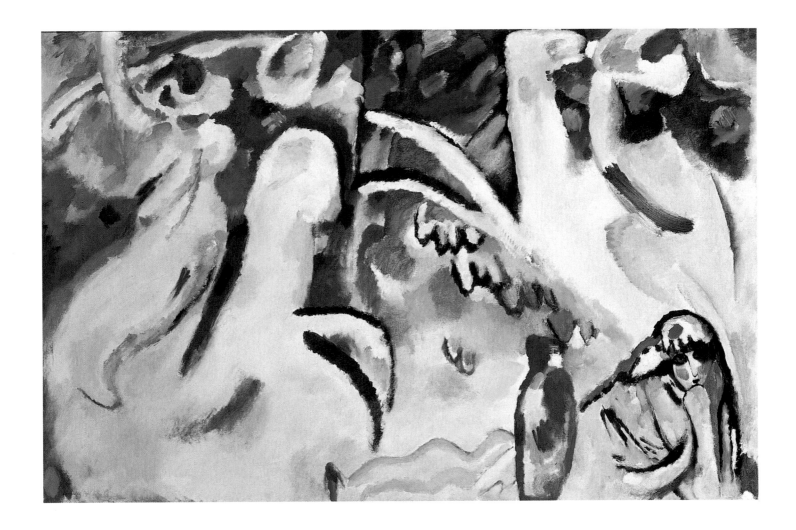

Picasso's Rose Period and *Les Demoiselles d'Avignon* there is no apparent evolution. Kandinsky strove to break through apparent reality to what Rilke termed *Überzahliges Dasein* — "surplus being." The swiftness with which Kandinsky made the transition from his Murnau discoveries to pure abstraction (a space of no more than two years) testifies to this aspiration. "Transition" is putting it mildly. It was an outlet, a breakthrough, so long awaited and desired.

Kandinsky began working in Murnau in August 1908. The intensity with which he worked during this period is stunning. He made sketches for theatrical performances that he intended to realize with the composer Thomas von Hartmann and the dancer Alexander Sakharov; he made plans for a musical "Album" in which his prints would share the same space with the music of Hartmann;[15] he engaged in theoretical investigations; he

Picture with a Circle, 1911.
Oil on canvas, ca 200 x 150 cm,
Museum of Fine Arts, Georgia.

Arabs III (in the pitcher),
Oil on canvas, 106 x 158 cm,
Picture Gallery of Armenia, Yerevan.

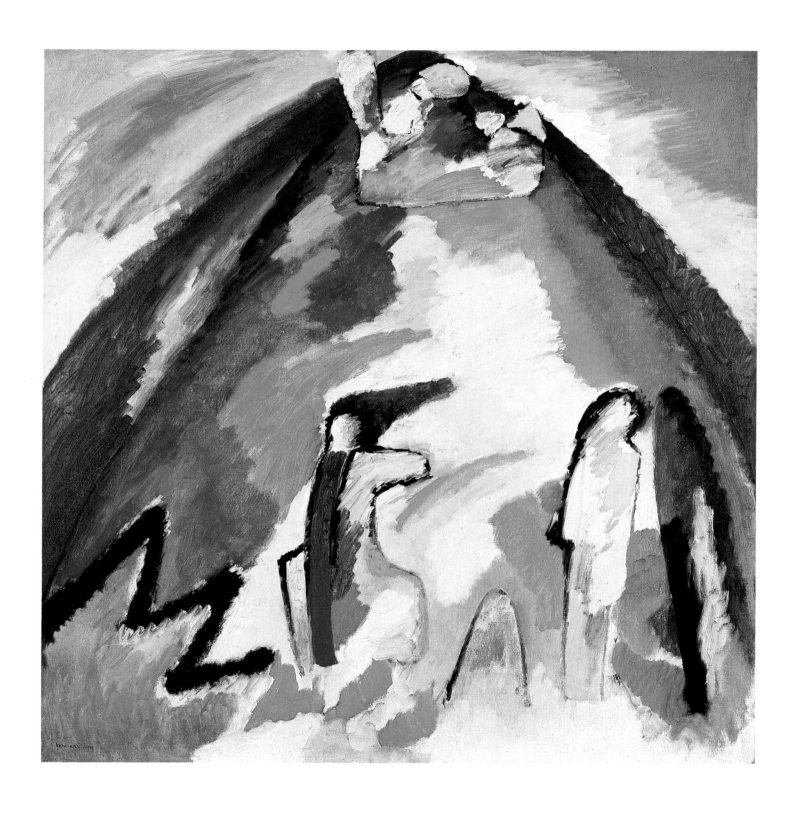

48

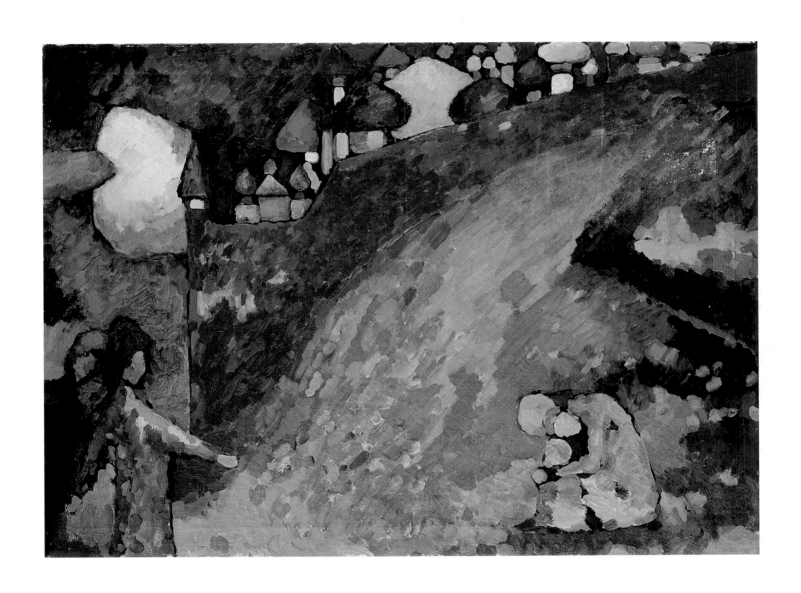

Mountain, 1908.
Oil on canvas, 109 x 109 cm,
Städtische Galerie im Lenbachhaus,
Munich.

Fatality, 1909.
Oil on canvas, 83 x 116 cm,
Koustodiev Gallery, Astrakhan.

prepared for the organization of yet one more artists' group, the Neue Künstlervereinigung München (New Artists' Association of Munich), whose president he would become in the following year.

But most importantly, during this time a revolution in his own art and in world painting took place, one with few equals and which, in its staggering significance, could be regarded as a sort of historical "master class," a lesson of courageous self-knowledge. Fifteen years later on, Hermann Hesse would began work on his immortal *Steppenwolf*, and the quest for the inner world would find strikingly adequate expression in literature: "You have a longing to forsake this world and its reality and to penetrate to a reality more native to you, to a world beyond time…You know, of course, where this other world lies hidden. It is the world of your own soul that you seek….I can throw open to you no other picture gallery but your own soul."[16] As we know, there was one fee for entering the theatre "for madmen only" — one's reason. But Kandinsky was not a hero of the lost generation of the years after the First World War. He had no need of a psychoanalyst's counsel (as, later, Hesse would) in order to construct his own artistic world. "The picture-gallery of the soul" was not a secret goal for him, but a natural means of self-realization, although one difficult to attain.

But how strong in him was the deep archetypal link with the most powerful nodes of German culture and its interpretations! We know that Kandinsky was close to the composer Schöenberg, conducted a friendly correspondence with him, translated his theoretical works, interested him in painting and later himself took an interest in Schöenberg's attempts in that direction. And there is no doubt that in *Doctor Faustus* Thomas Mann endowed his hero with the opinions and musical style (if not the fate) of Schöenberg.[17] But the essential, of course, lies elsewhere: in that deep link, whose roots can almost be traced back to the world of German prehistoric memory. For "the little blue green lake" (mentioned in a poem by Kandinsky) "caught [the] eye" of a character bearing the same name as the boy in *Doctor Faustus* — Nepomuk.

And, most importantly, the basis of art (so stunningly described by Mann) is the verbal illusion of music, that "grotesque little landscape"

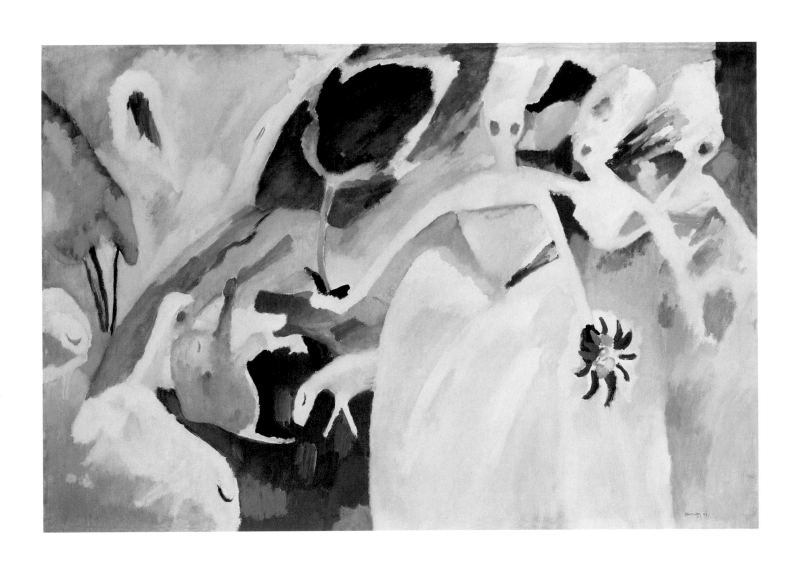

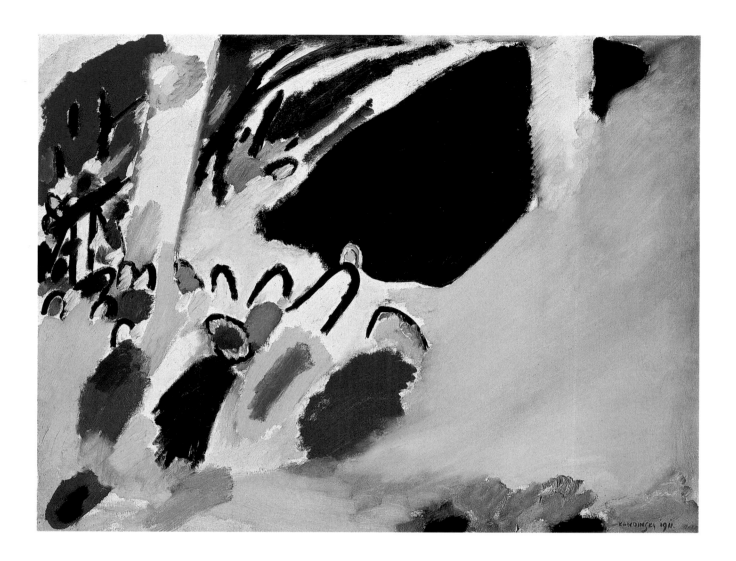

fashioned in a glass vessel, a landscape marked, not by "whimsical strangeness," but by "a profound sadness!"

In the end, the Murnau landscape became for Kandinsky that "nature which audaciously tempts the individual" to borrow the words of Thomas Mann. But it was not the nature in Murnau which revealed certain belated truths to Vasily Kandinsky. The time simply had come, and Murnau was the Place. There, in the mountainous outskirts of Munich, works and days long past gave forth luxuriant, almost excessive, impetuous shoots. The artist's gaze broke through the amalgam of reality that before had sent him stable pictures of the objective world. He saw the secret rhythms of color, line and form, for which things, nature, are no more than one of the functions marked by them. Kandinsky's transition from the object world to the world of pure forms was predetermined by his earlier trials and can hardly be interpreted as a loss or an acquisition. It is a given, without which he would never have become himself.

Impression III (Concert),
Oil on canvas.

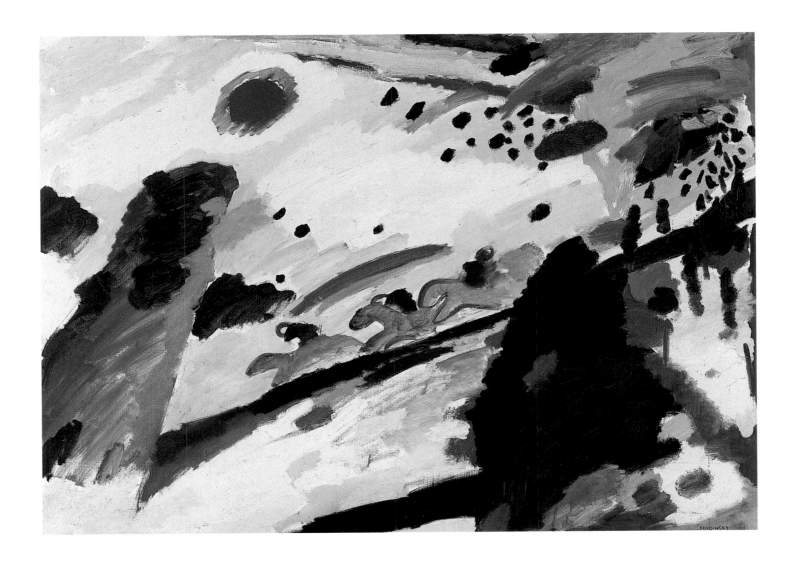

In his early Murnau landscapes it is not hard to recognize a Fauvist boiling of colors and abruptness in their juxtapositioning, the dramatic tension of Expressionism (which was gathering strength at that time), and the insistent texturedness of Cézanne.

However, what is surprising is that this recognition is purely rational, a kind of "intellectual correctness" on the part of the experienced viewer. It is quite apparent that Kandinsky did not construct his vision on the discoveries of his older contemporaries. For him, their art was part of the intelligible world and "Fauvist patching" was a part of reality. Through it, he rushed into his own world, a world that was still only half-open.

As a participant in the Salon des Indépendants exhibitions in Paris, Kandinsky was, of course, thoroughly familiar with the art of the Fauves (their last exhibition took place in 1907). Contemporaries often compared

Romantic Landscape, 1911.
Oil on canvas, 94.3 x 129 cm,
Municipal Gallery of Lenbachhaus,
Munich.

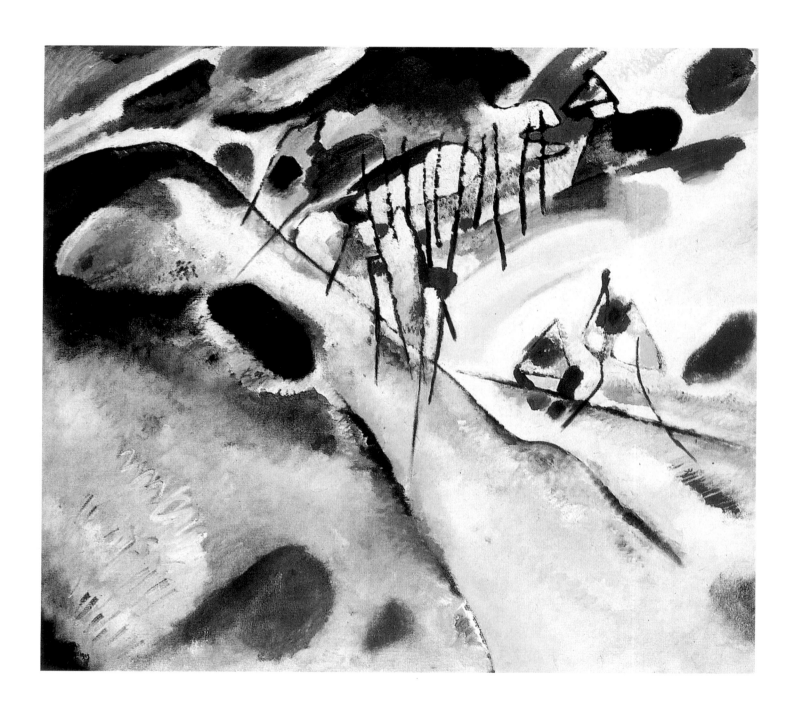

Landscape, 1913.

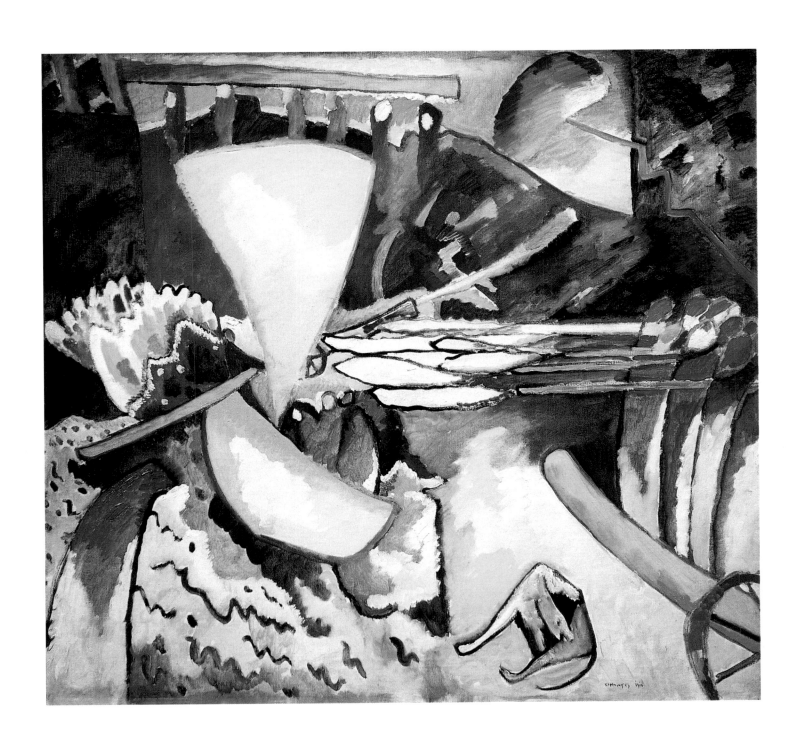

Improvisation II, 1910.
Russian Museum, St Petersburg.

the Fauves with the Expressionists. Sometimes Matisse and his confederates were termed "French Expressionists;" and, in the sixties, combined Fauvist/Expressionist retrospectives were held. The Fauves' fervid compositions had, however, a nature different from that of Kandinsky's severe and passionate strivings. The breakthrough of the outward appearance of the Murnau landscapes was for Kandinsky an entry into the emotional and spiritual essence of the universe. For the Fauves, painting was a means of free self-expression, a parade of painterly license.

Murnau was Kandinsky's Proustian "cup of tea": ". . . all the flowers in our garden and in M. Swann's park, and the waterlilies on the Vivonne and the good folk of the village and their little dwellings and the parish church and the whole of Combray and its surroundings, taking shape and solidity, sprang into being, town and gardens alike, from my cup of tea."[18] Murnau did not bring forth a flood of object associations and recollections of a strikingly loved childhood, but memories of the future (in the full sense of this phrase). Through the trees, mountain slopes and roads of Murnau and through its completely unfamiliar landscapes, the artist saw his painful past searches and a way into the future, into his own higher world, a world hidden for so long behind the all too material amalgam of material reality. He saw an outlet into a world he had not seen before, but whose existence he had guessed at and known as the sublime and principal reality.

Soldered into the canvas and, at the same time, bursting free of its material substance, the patches of color glimmer like living, breathing matter. In passing, they recall the objects which they signify, but literally right before our eyes they take on *Überzähliges Dasein* ("surplus being"), thus persuading our gaze and our consciousness that the yellow triangle, with its ragged outlines and black lacunae, is an incomparably higher and more significant value than the corner of the building it marks; that the alarmingly scarlet trapezium in the foreground, although it signifies the roof of a house, has a special, separate, sacred and endlessly beautiful meaning (*Murnau*, 1908, Tretyakov Gallery). In the Murnau landscapes, it is as if the viewer is present at the act of creation, at the birth of a new form of painting, one that, while still designating the world, is already detaching itself from it. A kind of solemn parting with the material world and the

Composition II, sketch, 1910.
Guggenheim Museum, New York.

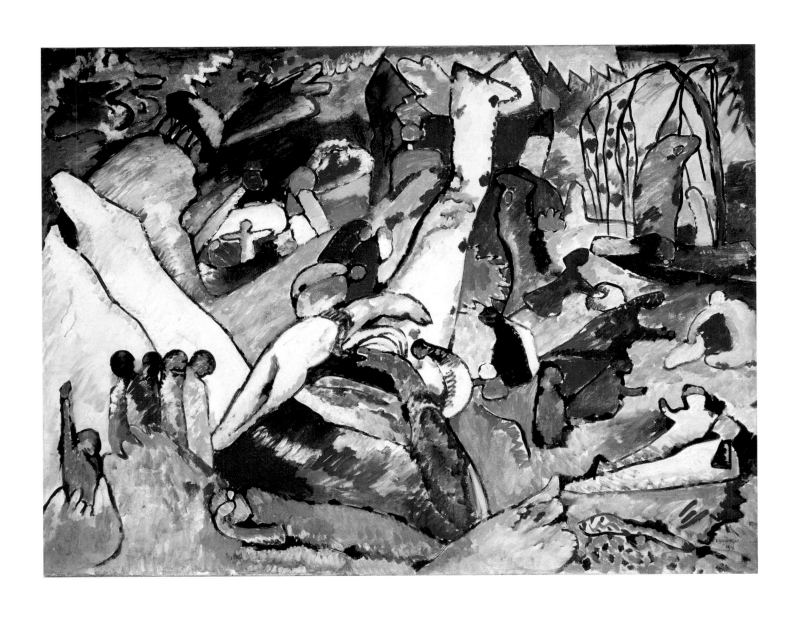

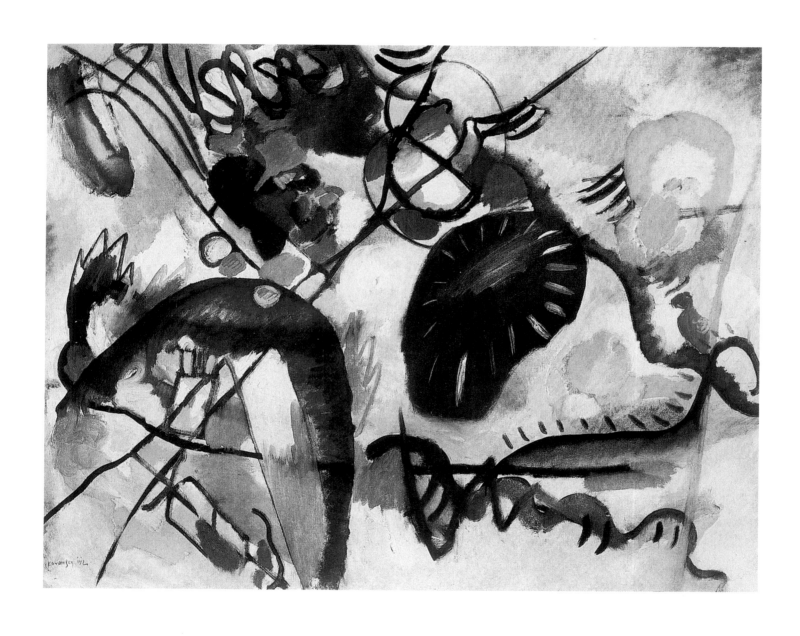

Black Spot I, 1912.
Oil on canvas, 100 x 130 cm,
Guggenheim Museum, New York.

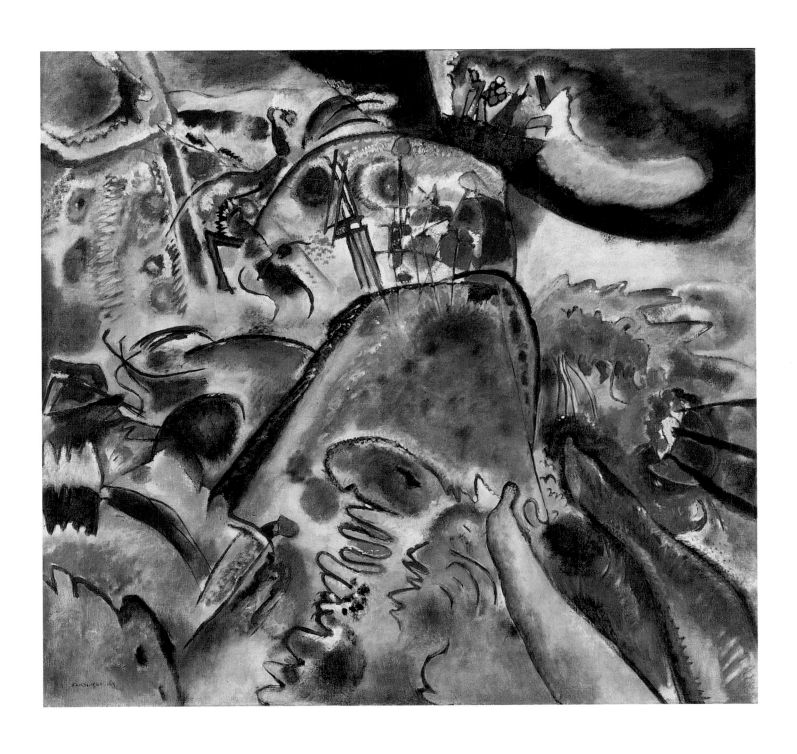

Small Pleasures, 1913.
Oil on canvas, 109.8 x 119.7 cm,
Guggenheim Museum, New York.

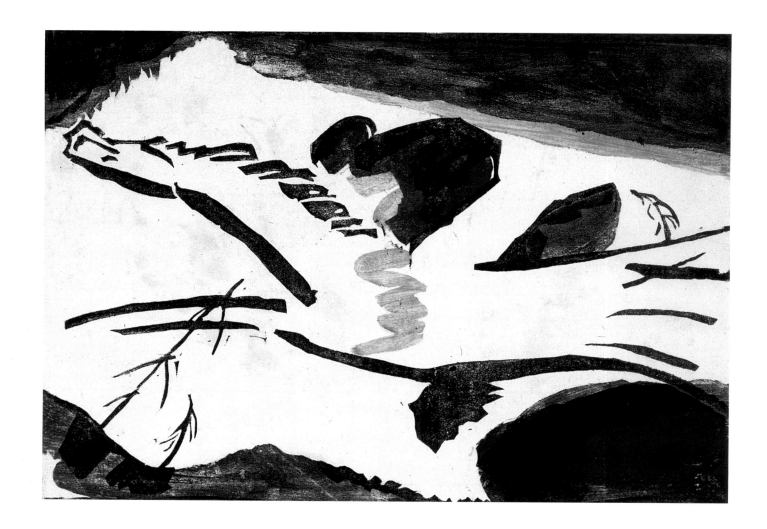

entry into a different world, a spiritual and liberated world, take place (*Summer Landscape*, 1909, Russian Museum).

The Impressionists made the painting's surface an independent value, but it bore, like an operatic aria, within itself musical and verbal information alike. Kandinsky entered a world of purely instrumental music and the observation of this process of liberation fascinates our minds to this very day.

Among Kandinsky's predecessors and contemporaries a kind of dialogue between reality and art had been preserved and within its field of tension an "artistic sacrament" was enacted. The classic example of such a dialogue was Cézanne's ability (as noted by Herbert Read) to find the structural configuration of objects separately from the objects themselves.[19]

The Cubism of Picasso in the years when Kandinsky was working in Murnau still attempted to preserve the object world, though in

Lyrics, 1911.

60

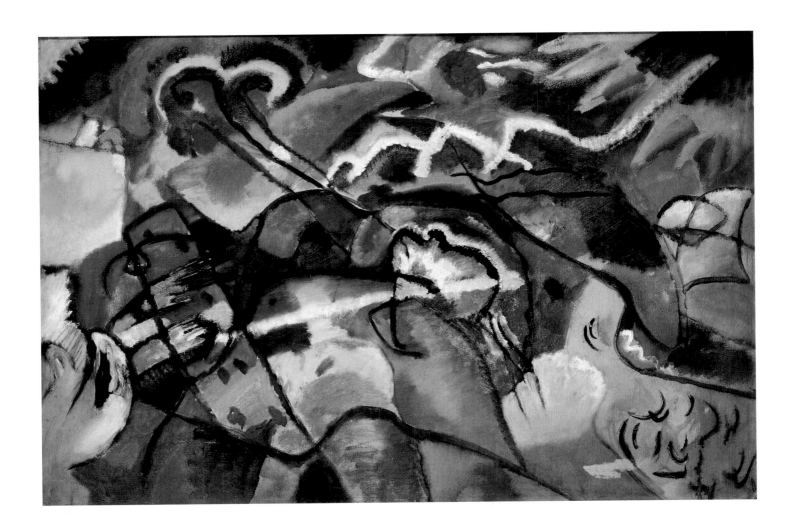

hitherto unseen speculative aspects. Delaunay pondered the transition from Impression to Cubism and assumed that the poetry of his 1911 works was not an abstract one.[20] Malevich was still seeking himself in the spatial world.

Kandinsky himself was leaving behind the earthly gravitational field of objects for the weightlessness of the abstract world, where the principal coordinates of being — up, down, space, weight — are lost. "For doom and resurgence to exist there must be a top and a bottom. But there is no top or bottom; these exist only in man's brain, which is the home of illusion," a character in Hesse's *Klingsor's Last Summer* would say ten years later. According to the myths (or revelations) of the twentieth century, by leaving reality behind, Kandinsky renounced illusion and, therefore, drew closer to a higher reality. Could it be that one of the fundamental paradoxes of the end of the millennium (a paradox to a great degree created by Kandinsky himself) lies here?

Painting with Black Border, 1913.
Oil on canvas, 70 x 104 cm,
Russian Museum, St Petersburg.

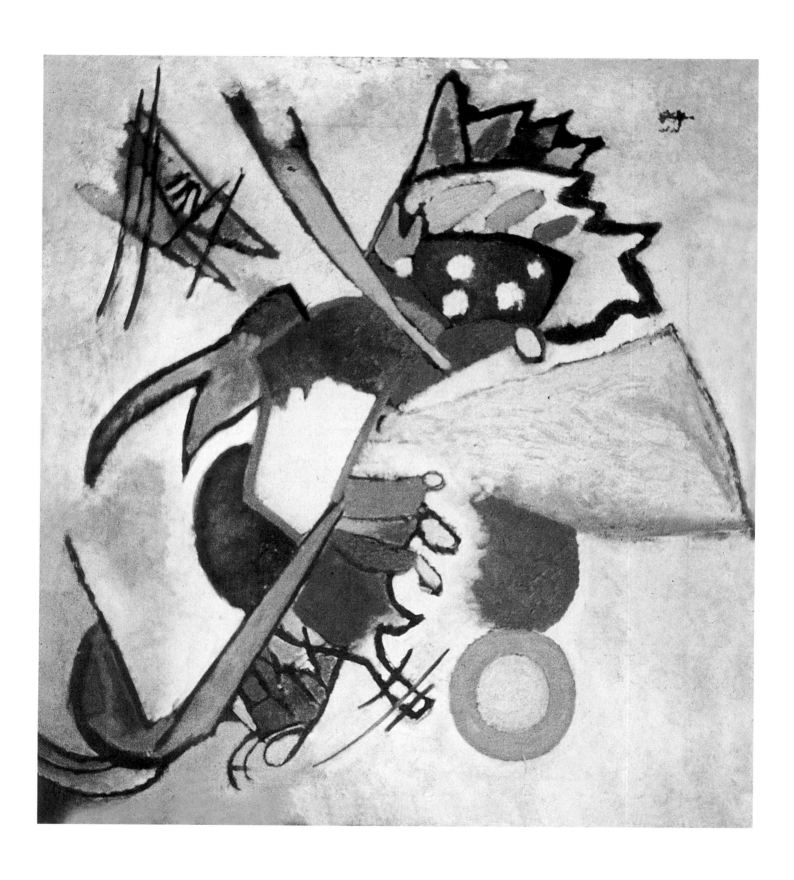

Between East and West

"It is the same everywhere: the great war, the great change in art...."
—Hermann Hesse, *Klingsor's Last Summer*

Kandinsky came back to Russia on two occasions. His first (relatively short) visit to Moscow took place from October to December 1912.[21] The second stay, a much longer one, kept the artist in Russia from December 1914 to December 1921. Kandinsky arrived in his native city at a time of "unheard-of changes and unprecedented revolts" (Alexander Blok). The artist himself knew no peace. The upward flight at Murnau had brought no certainty: the breakthrough to abstraction had not become final. Kandinsky wavered between what he had acquired and what he was in the process of acquiring. In these vacillations of his, however, one senses neither emotional strain nor cold calculation. It was simply his old desire to try "all tongues" again and again before settling on a single path. Who can say, perhaps he was lonely in the cold winds of the absolute freedom he had found?

He had already become well-known in the West. In 1911 the Blaue Reiter (Blue Rider) group had been founded; an anthology bearing that name, the *Blaue Reiter Almanach*, was published by the Piper Verlag the following year. (The book included artwork and essays by Blaue Reiter members, as well as articles on contemporary music by representatives of the so-called Second Viennese School including Arnold Schöenberg, Alban Berg and Anton von Webern.)

At the group's first show, in Munich's Thannhauser Gallery, Kandinsky exhibited more than forty works. Besides, paintings by the

Improvisation.

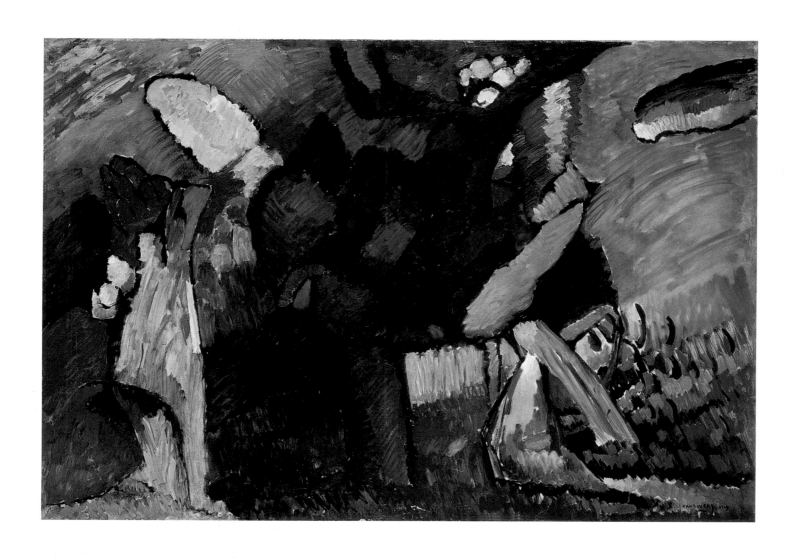

Improvisation IV, 1909.
Oil on canvas, 108 x 158 cm,
Museum of Fine Arts, Nizhni-Novgorod.

Improvisation VII, 1909.
Tretyakow Gallery, Moscow.

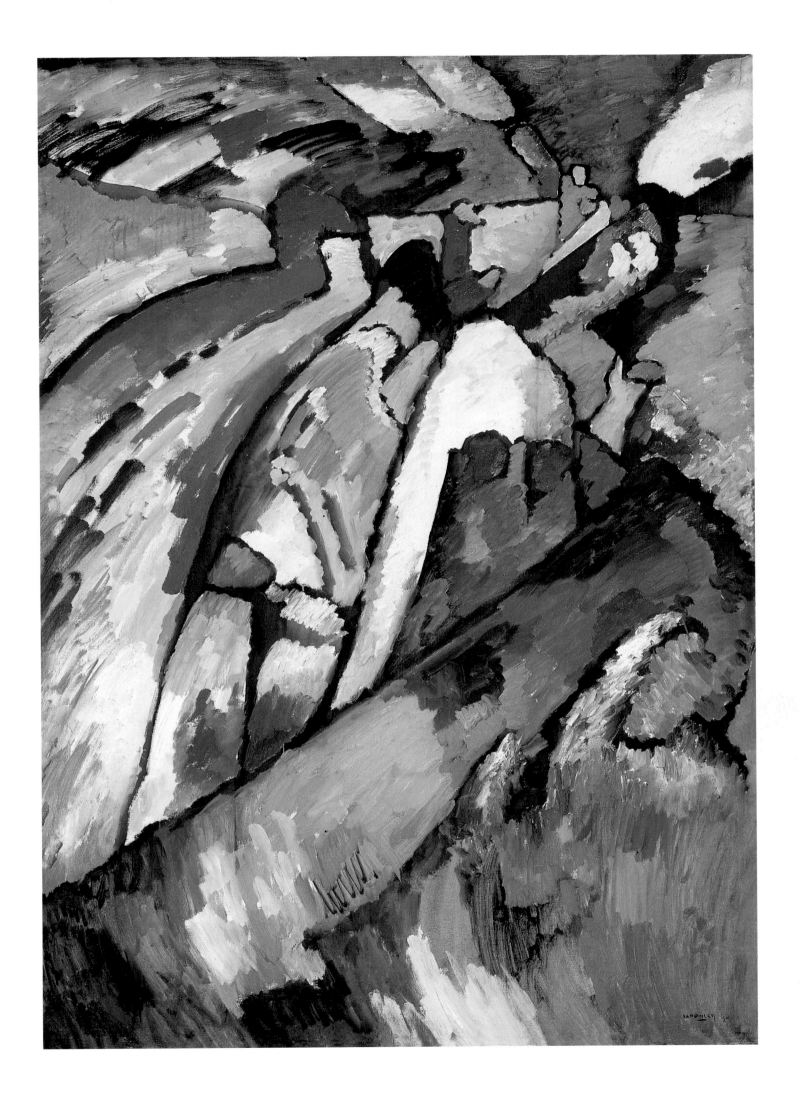

group's members, works by Delaunay and Henri Rousseau were exhibited, as well as the composer Arnold Schöenberg's attempts in that genre. Kandinsky was at the center of the Expressionist movement in Germany. At his side were other world-class talents, including his longtime confederate Alexei Jawlensky (with whom he had worked in Murnau), August Macke, Paul Klee, and Franz Marc. In early 1912 the Second Blaue Reiter exhibition was held, with the Russian artists Natalia Goncharova, Mikhail Larionov, and Kazimir Malevich taking part.

Kandinsky had already acquired a name in his homeland, Russia. His *Concerning the Spiritual in Art* was known from lectures and other accounts (the book was published during Kandinsky's first visit, in December 1912).[22] His articles were published in such Russian journals as *Apollon* (Apollo) and *Mir Iskusstva* (The World of Art). His works were on view in a number of Russian cities, including St. Petersburg. The paintings exhibited at the so-called International Salon of 1910-1911[23] — *Fate* (1909, Kustodiev Astrakhan Picture Gallery) and *Ladies in Crinoline* (1909, Treryakov Gallery) — represent a complex and powerful blending of living landscape, *passéist* Russian motifs, Symbolist mirages and triumphant abstraction.

At the same exhibition he presented his *Improvisations*, works practically free of materiality (*Improvisation 4*, 1909, Nizhni Novgorod State Art Museum; *Improvisation 7*, 1909, Tretyakov Gallery). Kandinsky was a participant in the first Knave of Diamonds exhibition (1910), where works similar to these were displayed. He had become, perhaps, one of the first stable transnational artists. Kandinsky had always paid close attention to the Russian art scene and now his sympathies were on the side of Aristarkh Lentulov,[24] David Burliuk and, to a significant degree, with Larionov and Goncharova.

Before the outbreak of the First World War, Kandinsky once again grew homesick for Moscow: "I've entered a period in my work where it's simply necessary for me to live in Moscow a few months . . . Moscow is the soil from which I draw my strength and where I can live the spiritual life so essential to my work."[25] It was then (1914) that Kandinsky returned to Moscow, where not only Vrubel and Serov had

Improvisation XX, 1911.
Oil on canvas,
Pushkin Museum of Fine Arts, Moscow.

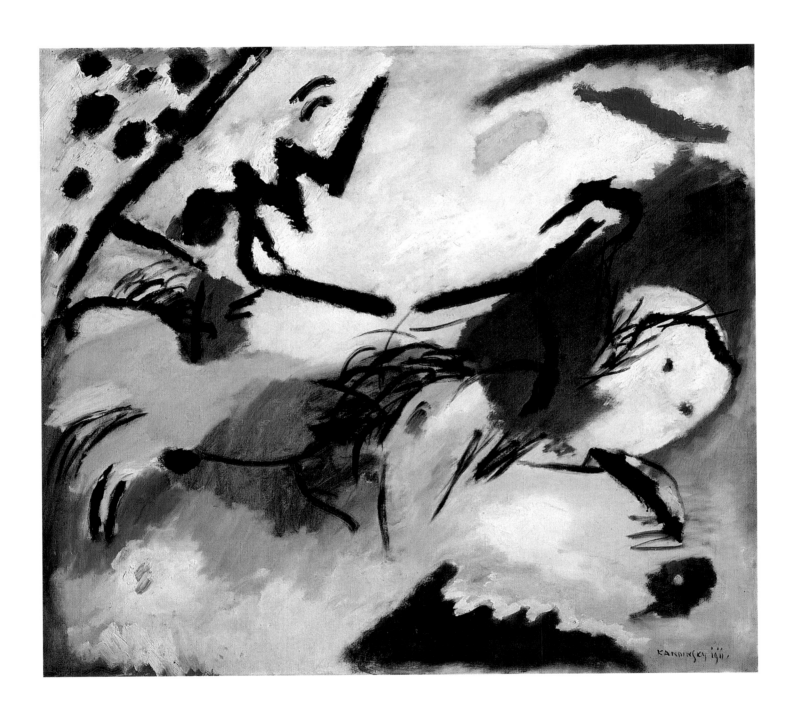

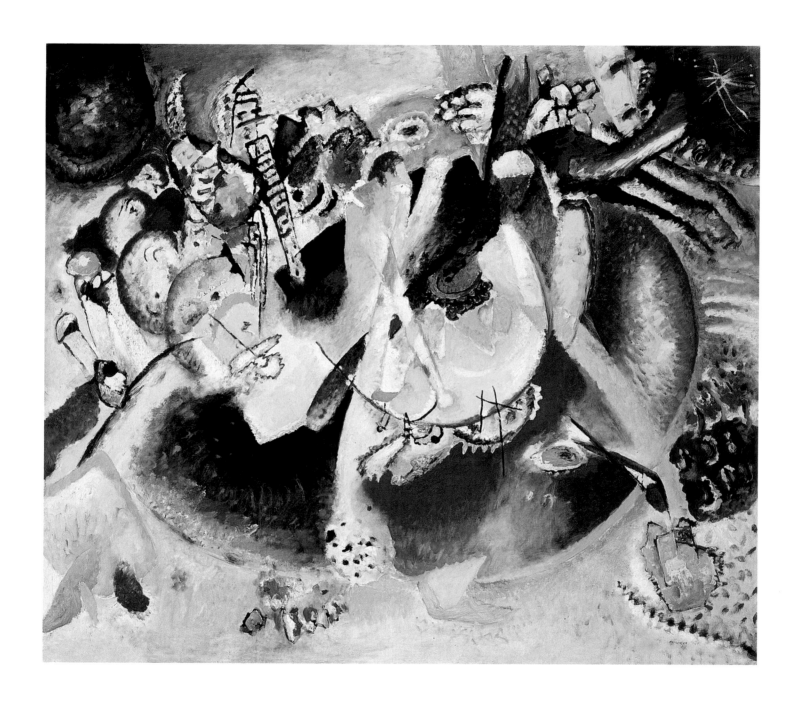

Improvisation with Cold Forms, 1914.
Oil on canvas, 130 x 140 cm,
Tretyakow Gallery, Moscow.

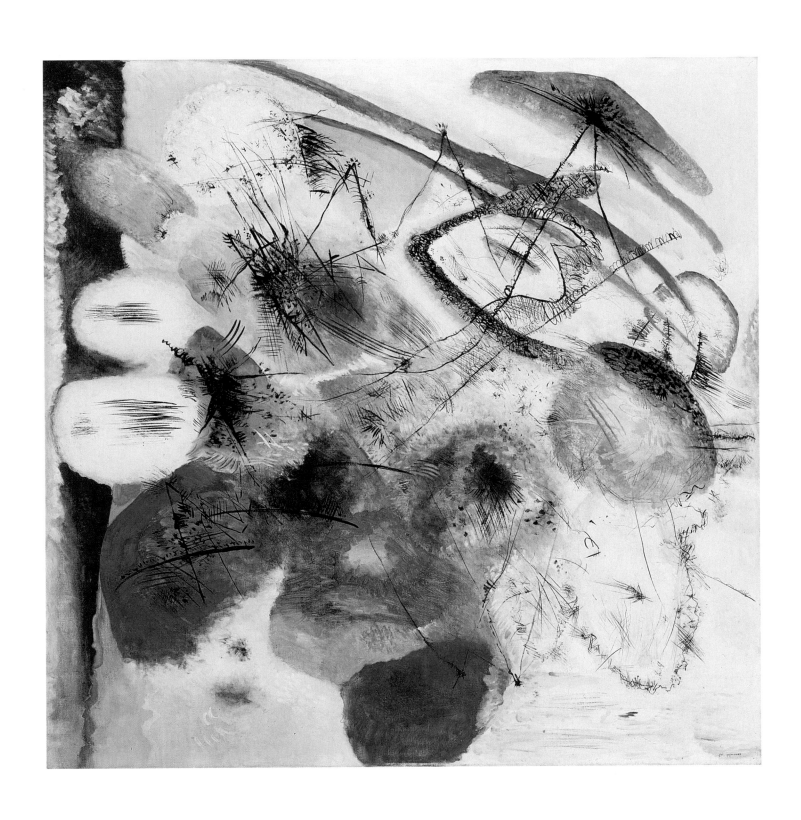

Black Lines I, 1913.
Oil on canvas, 129.4 x 131.1 cm,
Guggenheim Museum, New York.

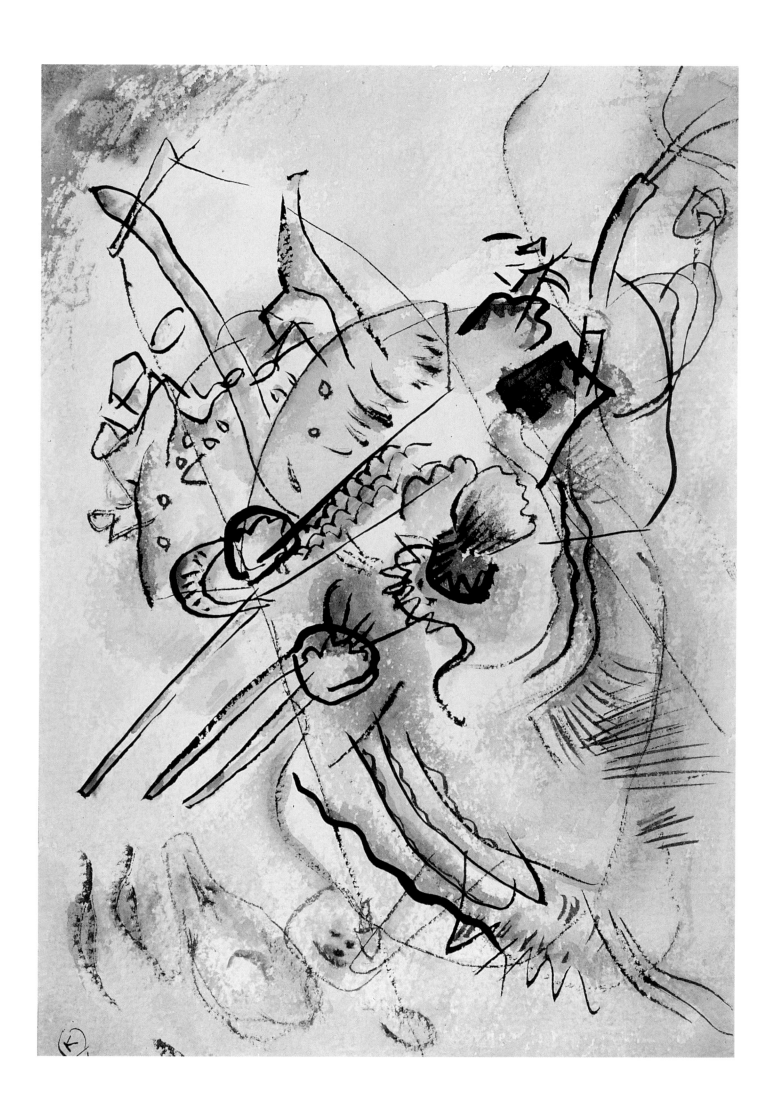

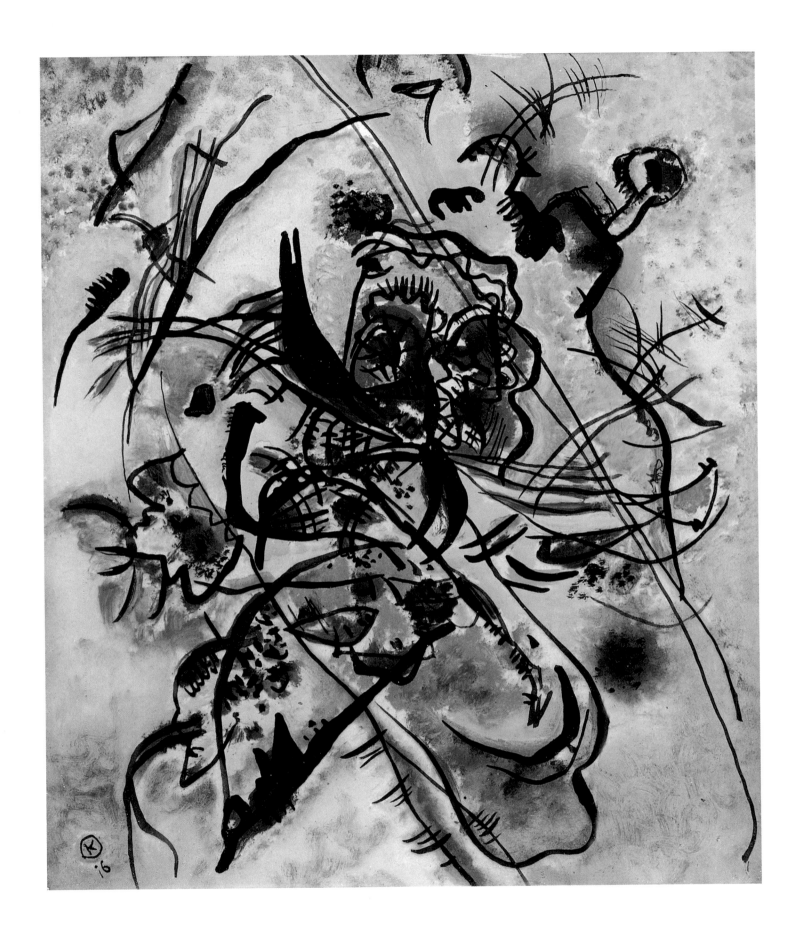

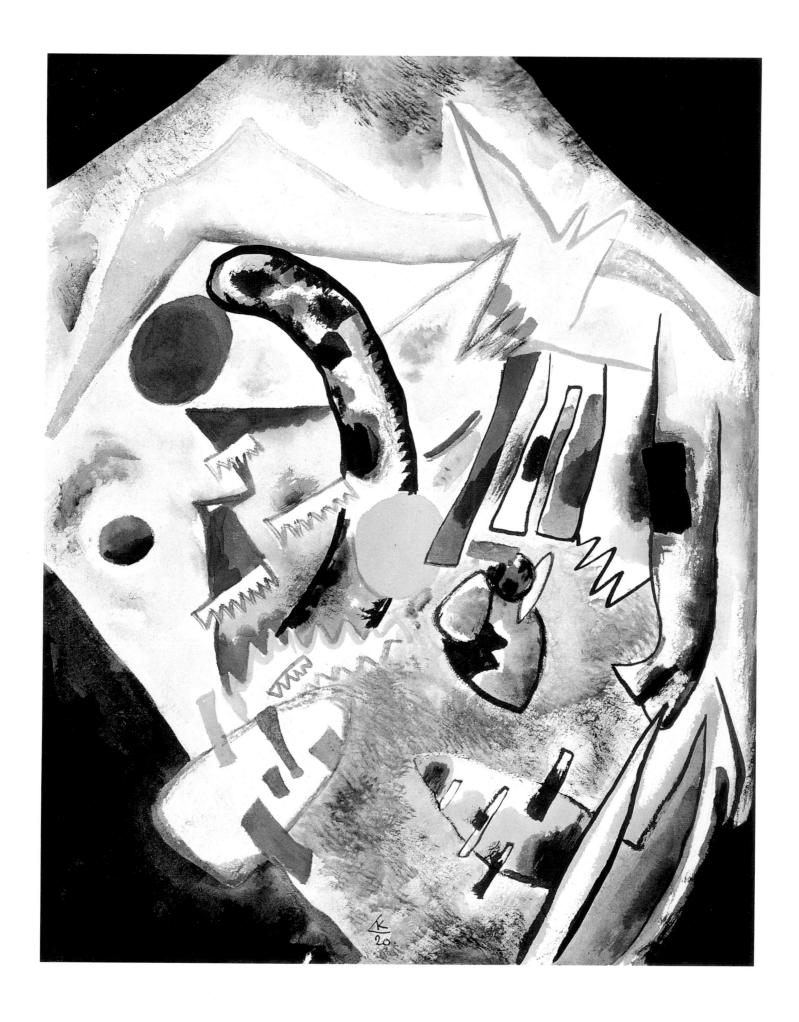

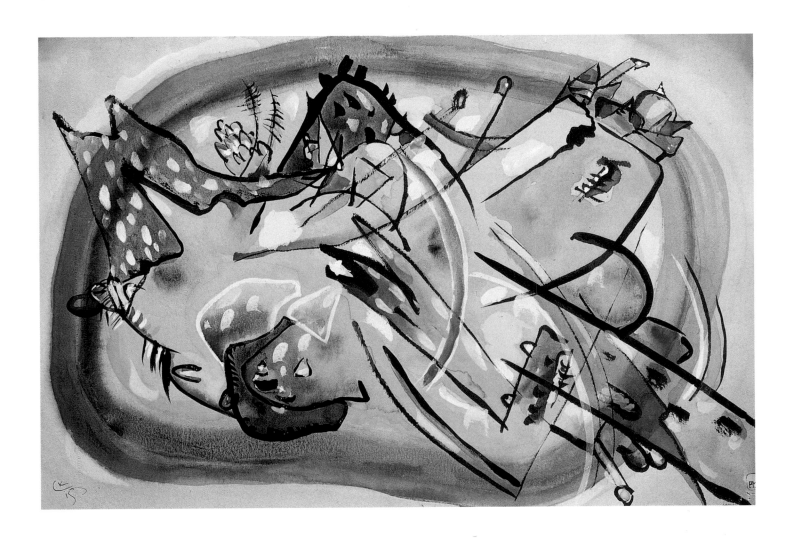

long before become history, but where the 1913 exhibition — at which Malevich had presented his abstractions and the first manifesto "From Cubism to Suprematism" — had ceased being a sensation.

Kandinsky had been and remained a free artist — he never became hostage to his own theoretical conceptions. Many might have been taken aback by the romantic ingenuousness of his wholly figurative Moscow landscapes. This ingenuousness is only apparent, however. It is as if the artist were trying to catch sight of and to realize a real cityscape as it unfolds in space and time (memories of the artist's own youth) with the aid of the new "optics" which had emerged in Murnau. Houses, clouds, trees, the snowy fog: these things arise in the paintings as if from the particles of a kind of "non-figurative mosaic." A process asymmetrical to what happened at Murnau appears: a likeness of earthly reality is constructed from "non-figurative" elements. The primary formulae of color blocks is here not the outcome of artistic

Page 70:
Composition D

Page 71:
Composition, 1916.
Oil on canvas,
Gallery of Paintings, Tioumen.

Page 72:
Composition A.

Page 73 :
Composition. Landscape,
Watercolor, India ink and white
on paper,
Russian Museum, St Petersburg.

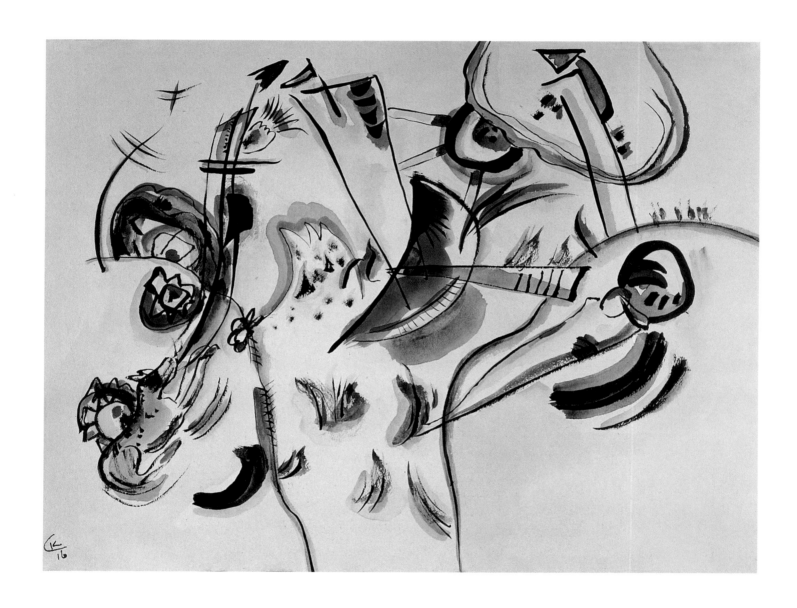

Composition V.

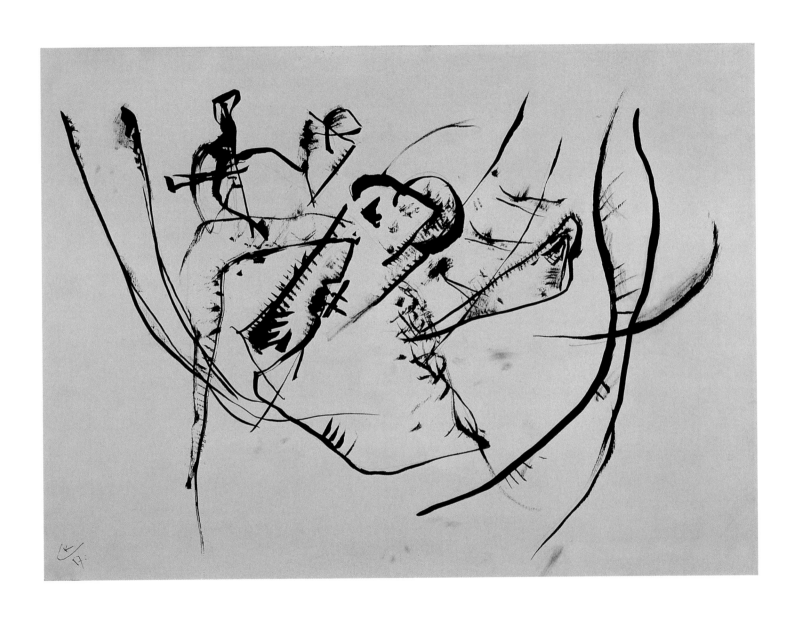

Composition Landscape, 1915.
Watercolor, India ink and white on paper,
Russian Museum, St Petersburg.

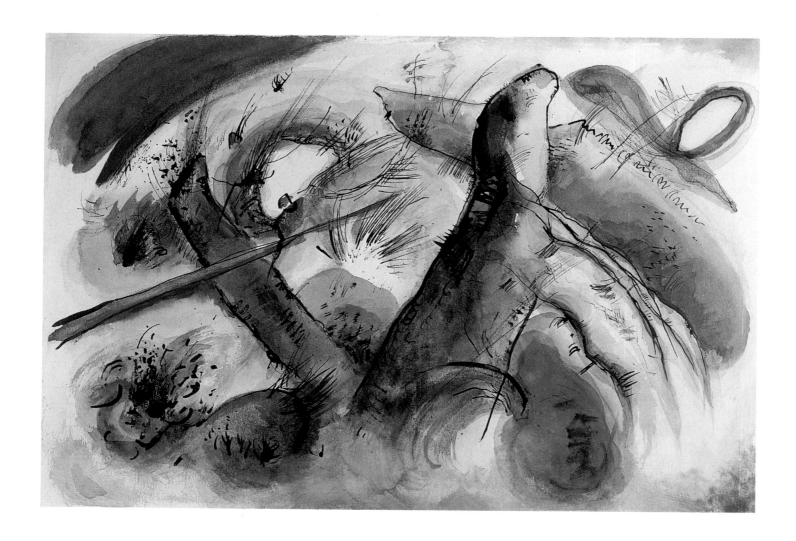

Composition E.

Composition III.

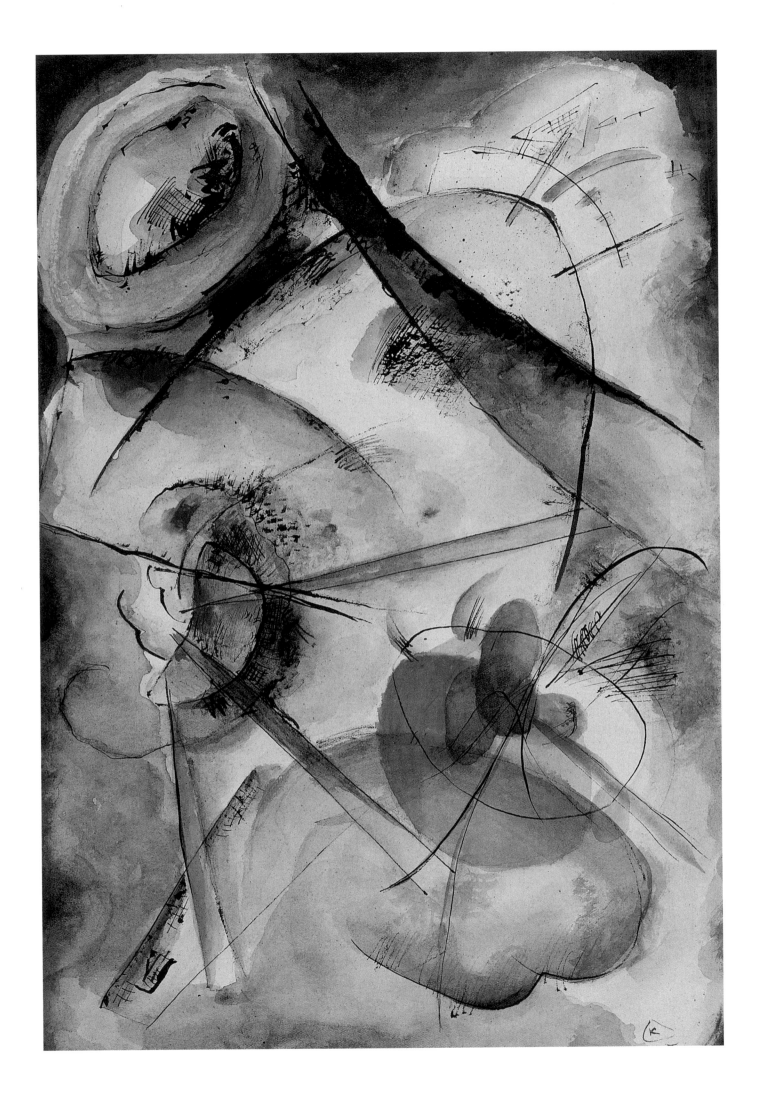

insight, but becomes, rather, a new instrument for understanding the world (*Moscow. Zubovsky Square*, c. 1916, Tretyakov Gallery; *Winter Day. Smolensk Boulevard*, c. 1916, Tretyakov Gallery).[26] The transnational context in which Kandinsky was at home introduces into his paintings (e.g., *Moscow. Red Square*, 1916, Tretyakov Gallery) the sensation of a falling world devoid of horizontals and verticals, a sensation characteristic of the works of Delaunay and Chagall during this same period.

Kandinsky's works on glass represent a stunningly original line in his art. There is no doubt that they, too, have their roots. Even when not held up to light, glass preserves the effect of a slightly transparent mirror. It calls to mind both the spectres of Russian fairytales and lubki (cheap popular prints) which once again appeared among Moscow's cupolas, and the stained-glass windows of Gothic cathedrals as seen from without. It calls to mind Rouault's bewitching phantasmagoria, radiant old icons and the radiance of Vrubel's crystals. Of course, painting on glass is a fairly unusual phenomenon, but Kandinsky — for whom the past, symbolism and a passionate interpretation of contemporaneity were invariably linked — was partly ahead of his own time: soon a universalism of techniques would become the norm. And Tatlin's counter-reliefs and Duchamps' already completed experiments (not to mention works so well-known and traditional in that period as Vrubel's majolica) — weren't they the natural milieu for Kandinsky's wide searches?

The more so were his non-figurative compositions from the 1910s of primary importance for the future, a decisive step into that world of the spirit to which Kandinsky had aspired for so long and with such determination. He was already in his fifth decade. None of the titans of the avant-garde had ever come into his own at such a late age in life.

Vladimir Solovyov had written as early as 1890 that one of the fundamental principles of art "is the transformation of physical life into spiritual [life]." And although since the time of Plato many philosophers had written more or less about this, "spirituality" as a

Composition VII, 1913.
Oil on canvas, 200 x 300 cm,
Tretyakow Gallery, Moscow.

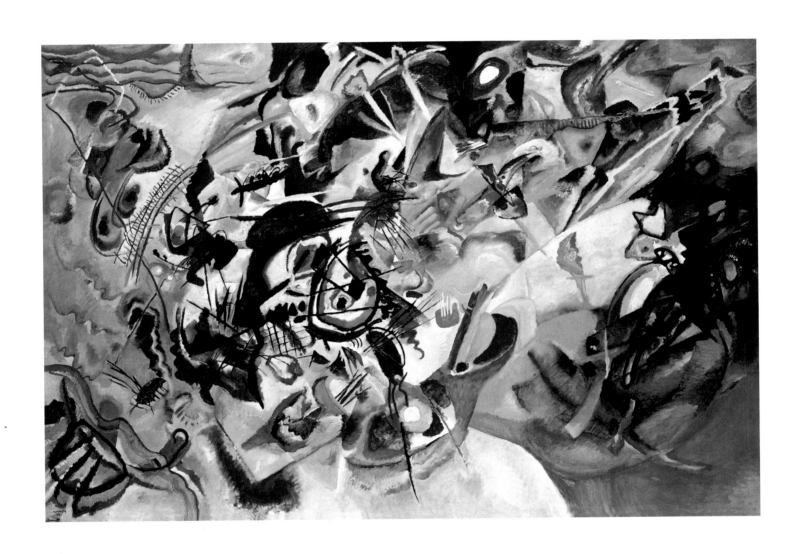

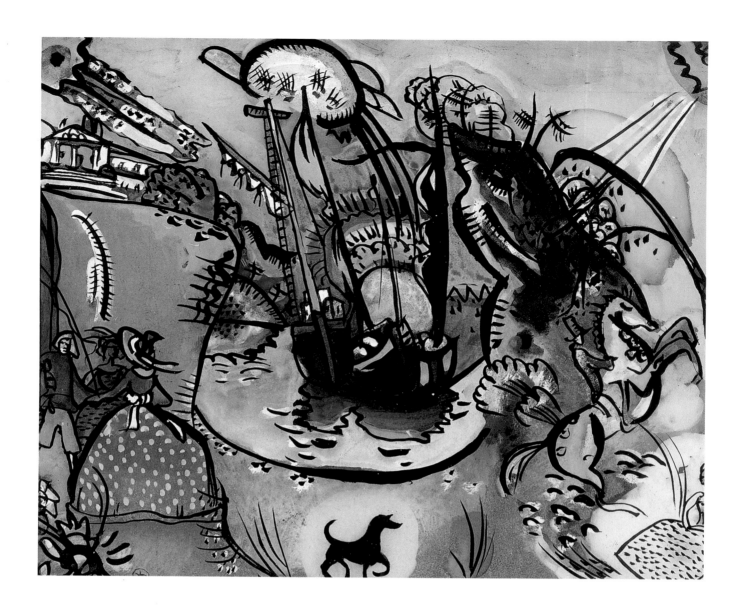

Harbour, 1916.
Oil on foil, glass, 21.5 x 26.5 cm,
Tretyakow Gallery, Moscow.

particular category of art seemed at this time to be an almost new phenomenon and occupied Kandinsky as nothing else did. It was not without reason that Kandinsky dedicated his principal written work, *Über das Geistige in der Kunst (Concerning the Spiritual in Art)*, to this problem.

Like the majority of modernist artists, Kandinsky was unable to conceive of his work without theory and interpretation. But it was not so much his works which he explained as a system of ideas. His books are worth reading independently of their relationship to his paintings, just as his paintings can be interpreted without his texts. There was no one who aspired to synthesis as did Kandinsky, but likewise there was no one who so aptly conceived so many fascinating philosophical tracts and paintings and esthetic revelations.

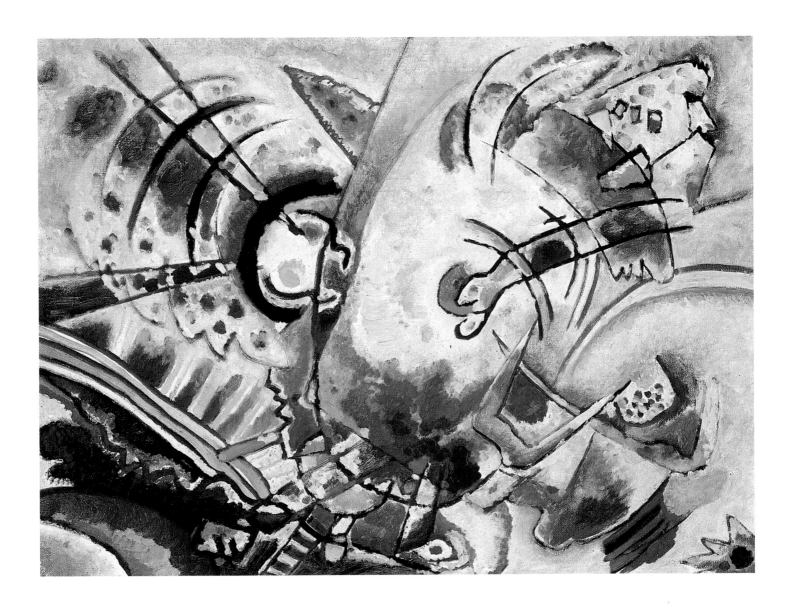

Of course, the constant parallels with music of which Kandinsky made use (in this he was not alone), thus showing the kinship of expressive means, are most likely dated. Music had always expressed without depicting. The viewer subconsciously looks for (and finds) space, volume and associations with the object world in a picture (no matter how "abstract" it is). Color is hardly divisible from the object; what is more, it prompts associations with the object even when the artist does not intend this.[27] The exit into abstraction is never complete, but the road to it is of primary value to art.

Complete weightlessness is probably impossible as well: having broken free of the earth's gravity, objects (like planets in the universe) begin to gravitate towards each other. Strictly speaking, Kandinsky depicts a similar process. In his *Compositions* and *Improvisations* (in which

Untitled, 1916.
Oil on canvas, 50 x 66 cm,
Museum of Fine Arts, Krasnodar.

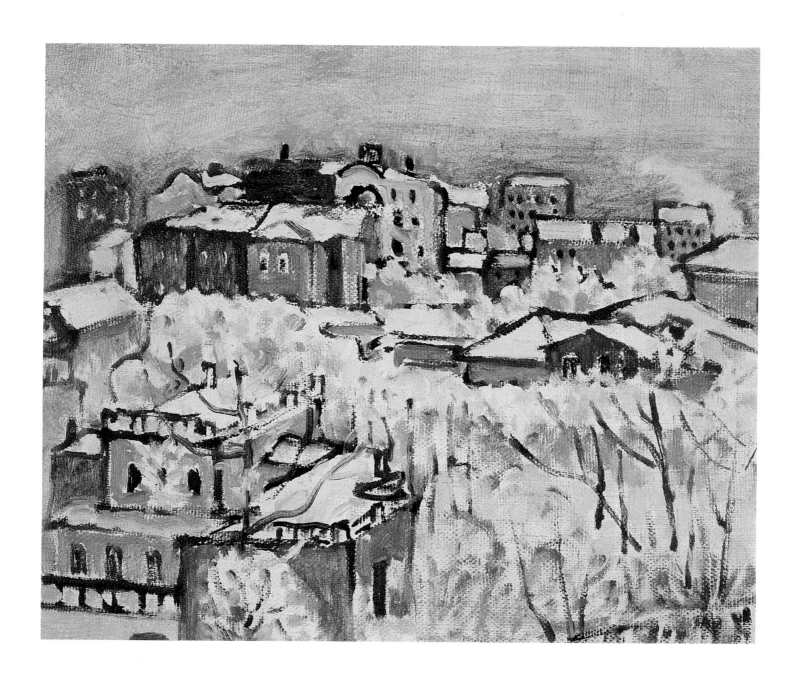

Winter Day. Smolenski Boulevard, ca
1916.
Oil on canvas, 26.8 x 33 cm,
Tretyakow Gallery, Moscow.

Twilight, 1917.
Oil on canvas, 91.5 x 69.5 cm,
Russian Museum, St Petersburg.

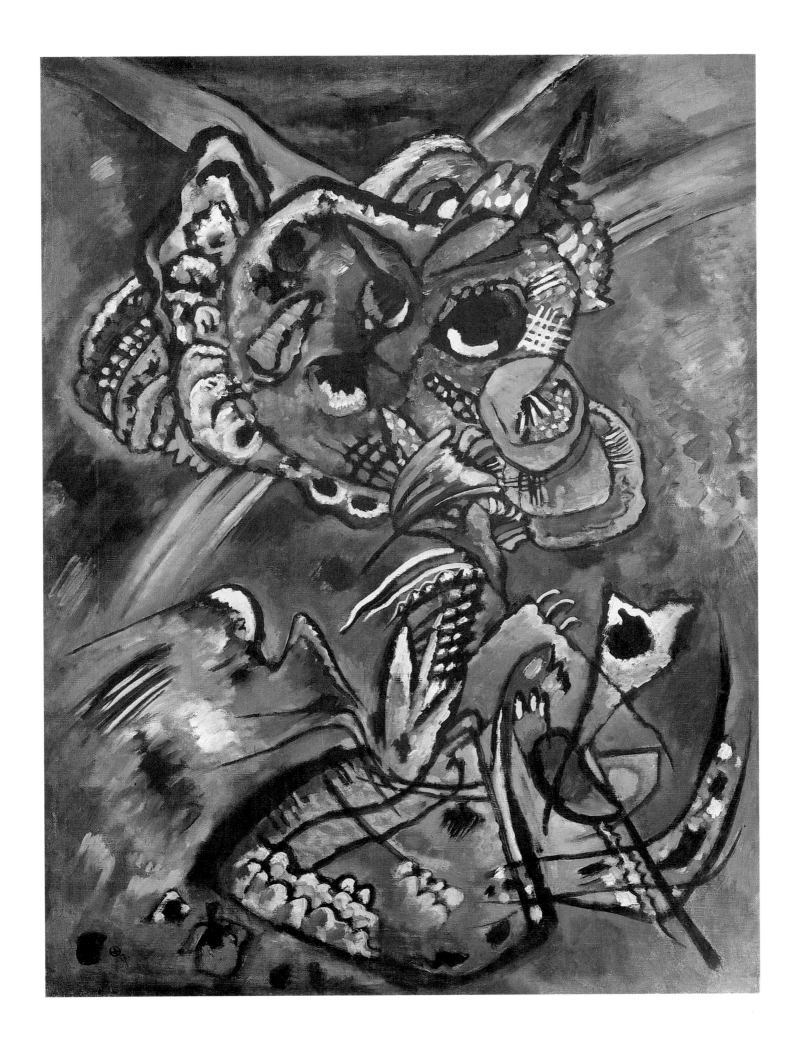

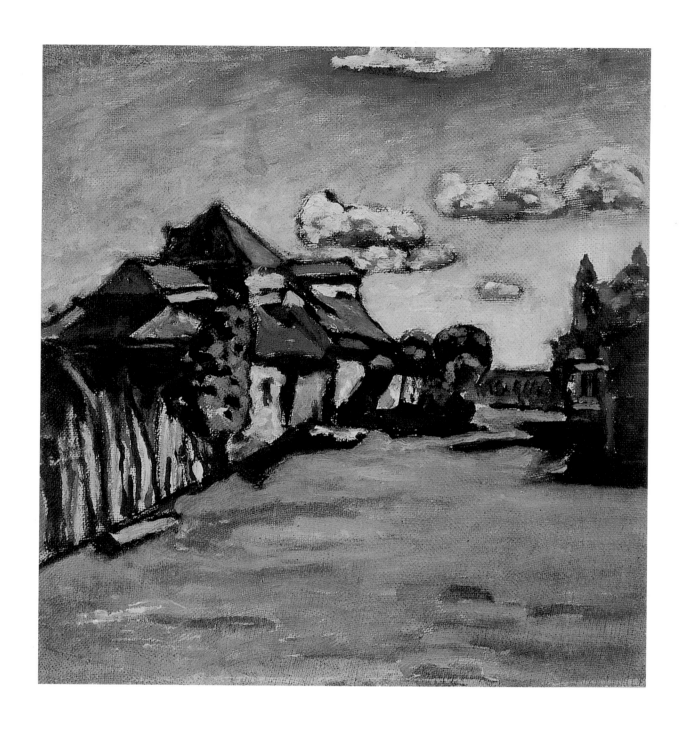

Suburbs of Moscow,
Oil on canvas mounted on cardboard,
26.2 x 25.2 cm,
Tretyakow Gallery, Moscow.

the artist is almost liberated from weight and space) two poles of the argument with the world of things emerge: the similarity of his abstract forms with living matter, and a certain planetarity, the sense of certain galactic systems which are too much bound up with one other to be perceived as anything other than the creations of an artistic, fairly rational consciousness.

But Kandinsky considered himself a Romantic (in the eternal and profound sense of the word) and was convinced that the art of the future belonged to Romanticism.[28] It is curious that, next to the insistent rationalism of Malevich (who, in this context, might have been

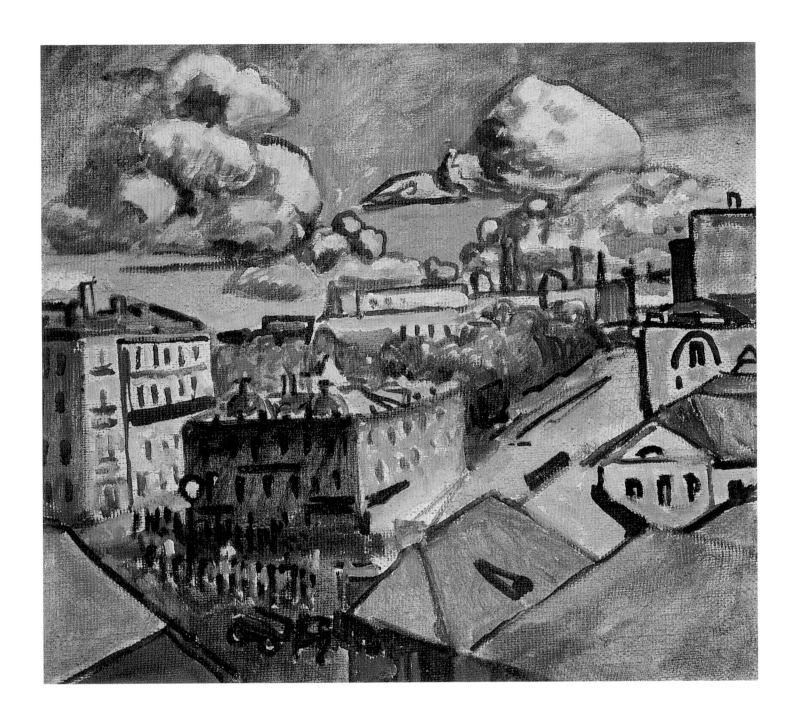

categorized as representing an avant-garde "classicism"), Kandinsky's emotionalism was indeed similar in spirit to Romanticism. And, on the contrary, the impulsiveness and (albeit occasionally brilliant) incomprehensibility of Malevich's texts allow one to perceive the strict logic in Kandinsky's writings.

It goes without saying that Kandinsky's "textbook" abstract works are fed by a powerful and complicated system of roots encompassing much of which we have already spoken, including the art of the Russian icon.[29] But in the mature, wholly non-figurative works, the origin is hidden in the deep underground, thus allowing the artist to

Moscow, Zubovsky Square, ca 1916.
Oil on cardboard,
34.4 x 37.7 cm,
Tretyakow Gallery, Moscow.

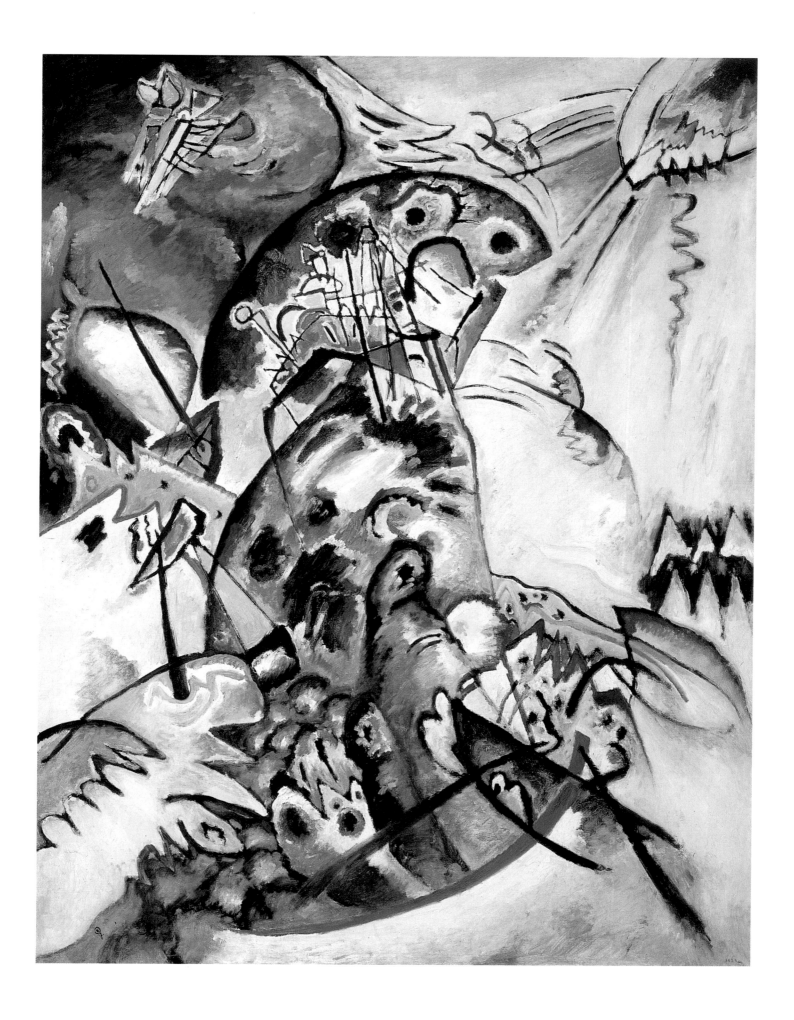

86

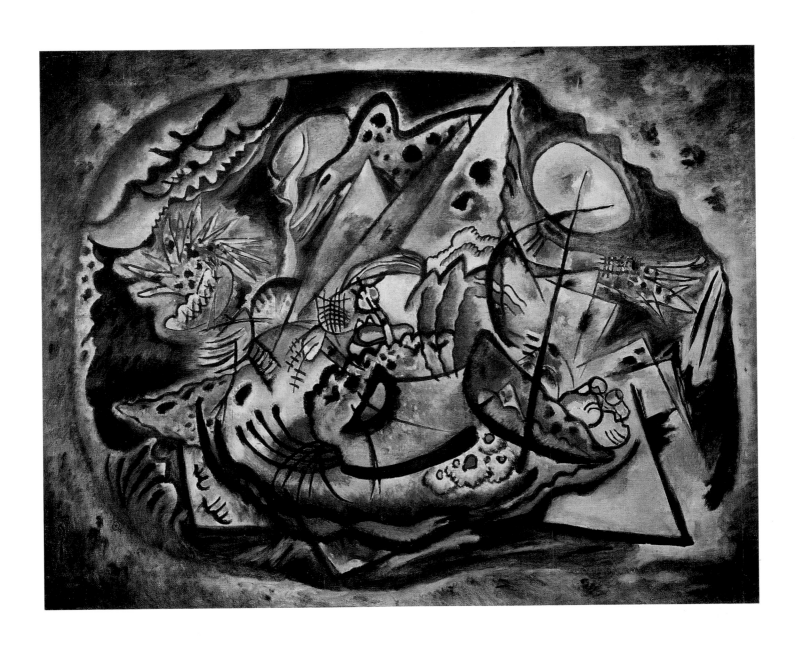

Blue Comb, 1917.

Grey Oval, 1917.
Oil on canvas, 104 x 134 cm,
Picture Gallery, Ekaterinburg.

escape "from probability into rightness" (Pasternak). No one has described better that eternal arabesque of associations than the champion of committed and moral art, Leo Tolstoy. "[H]e's so narrow, somehow, like a clock on a wall . . .

Narrow, you know, grey, light-colored," says Natasha Rostova of another character in *War and Peace*. Of Pierre, she comments: "[H]e's blue, dark blue and red, and he's quadrangular."[30] All these things had lived in consciousness, had been fleetingly glimpsed in art, but as something strange, "other," something still awaiting a genuine artistic discovery.

And in mid-1910 Kandinsky brought a cyclopean and hitherto unseen universe crashing down onto the artistic consciousness of viewers and his own colleagues. Up until this time there had been very little abstract painting. Malevich's experiments for the most part were interpreted as artistic manifestos rather than the emotional plasma, the visual lava, of modernist culture. It was from the paintings of Vasily Kandinsky that this lava was pouring forth.

His early non-figurative compositions were by no means greeted as a joyous revelation (even the sunny and artless Impressionists were accepted slowly and unwillingly, after a number of scandals). These works were as piquant and unusual (forgive us for the comparison) as the first spices, the first opium, hops and tobacco smoke. They were as the first rhymes, the first organ and the first moving picture. They were what people had lived without for ages; but, once they had experienced these new sensations, they began to wonder how it was that they had lived without them before. Non-figurative paintings provided art with a new environment: now that it was able to demonstrate and to comprehend its naive weaknesses, as well as its eternal prerogatives, figurative art began to exist as an ever-present alternative.

Vasily Kandinsky's abstractions are filled with a coded, impersonal, "organic" life reminiscent of the plants in Mann's *Doctor Faustus*. Not only because in Kandinsky's abstract forms there appear at times simply likenesses of anthropomorphic and zoomorphic apparitions and the "artistic substance" in his paintings is invariably mobile. But, first and

Moscow, Red Square, 1916.
Oil on canvas, 51.5 x 49.5 cm,
Tretyakow Gallery, Moscow.

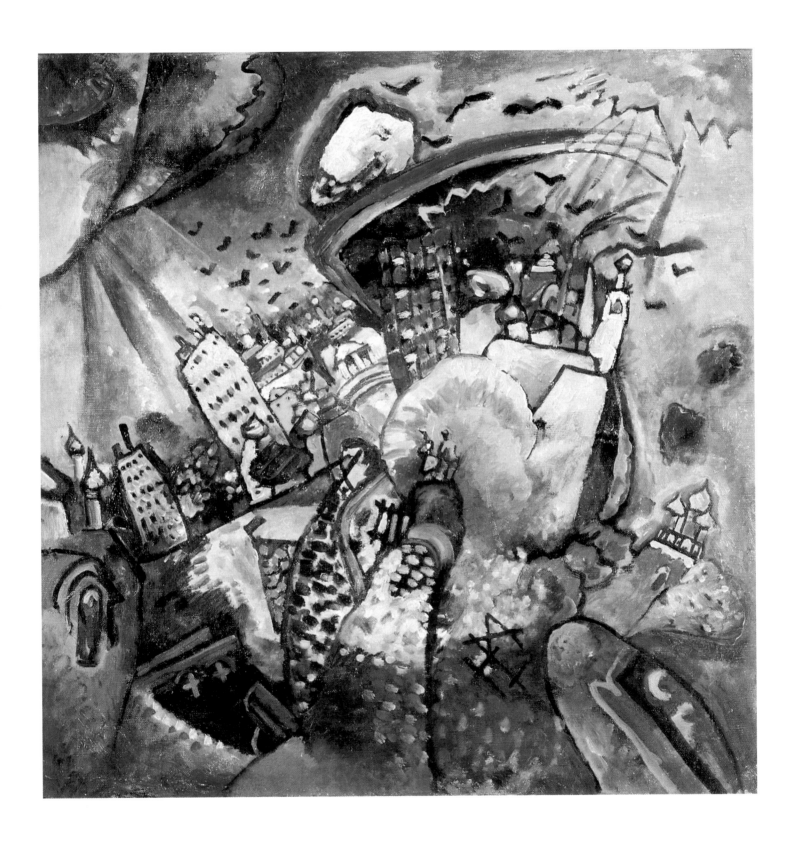

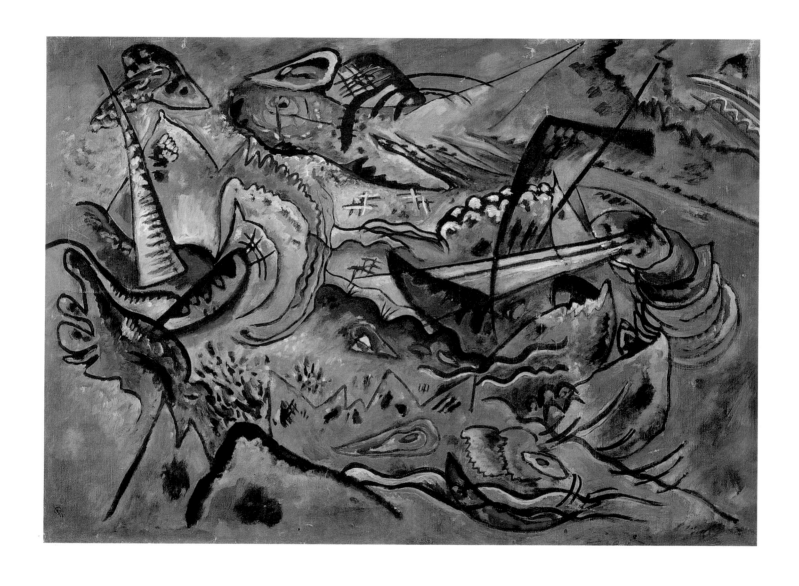

Southern, 1917.
Oil on canvas, 72 x 101 cm,
Art Gallery, Astrakhan.

Moroseness, 1917.
Oil on canvas, 105 x 134 cm,
Tretyakow Gallery, Moscow.

foremost, because his pictorial world (as opposed to Malevich's) never gravitates towards weightlessness, towards "absolute zero" and absolute harmony. ("There is no absolute," writes Kandinsky in *Concerning the Spiritual in Art*.) Kandinsky's world is in the process of becoming. Sometimes it seems that Kandinsky had a presentiment of the mobile semblances of "virtual reality": like the cells in living matter, his clots of color are, as it were, captured in motion; they are on the verge of unfolding in space, flowing into one another, disappearing. The pessimist might be tempted to see a paraphrase of mutation in Kandinsky's vague, dynamic, fluctuating phantoms; the optimist, eternal renewal; the philosopher, the closed circle of being.

And it is then that what forever will become a constant in the work of Kandinsky makes its appearance: The unity of great and small.[31]

Page 92:
Picture with Points, 1918.
Oil on canvas,
Russian Museum, St Petersburg.

Page 93:
Composition on Brown, 1919.
Watercolor, India ink, pen and white on paper,
Pushkin Museum of Fine Arts, Moscow.

Page 94:
Amazon, 1918.
Glass-painting, 32 x 25 cm,
Russian Museum, St Petersburg.

Page 95:
Rose Knight, 1918.
Glass-painting,
Russian Museum, St Petersburg.

94

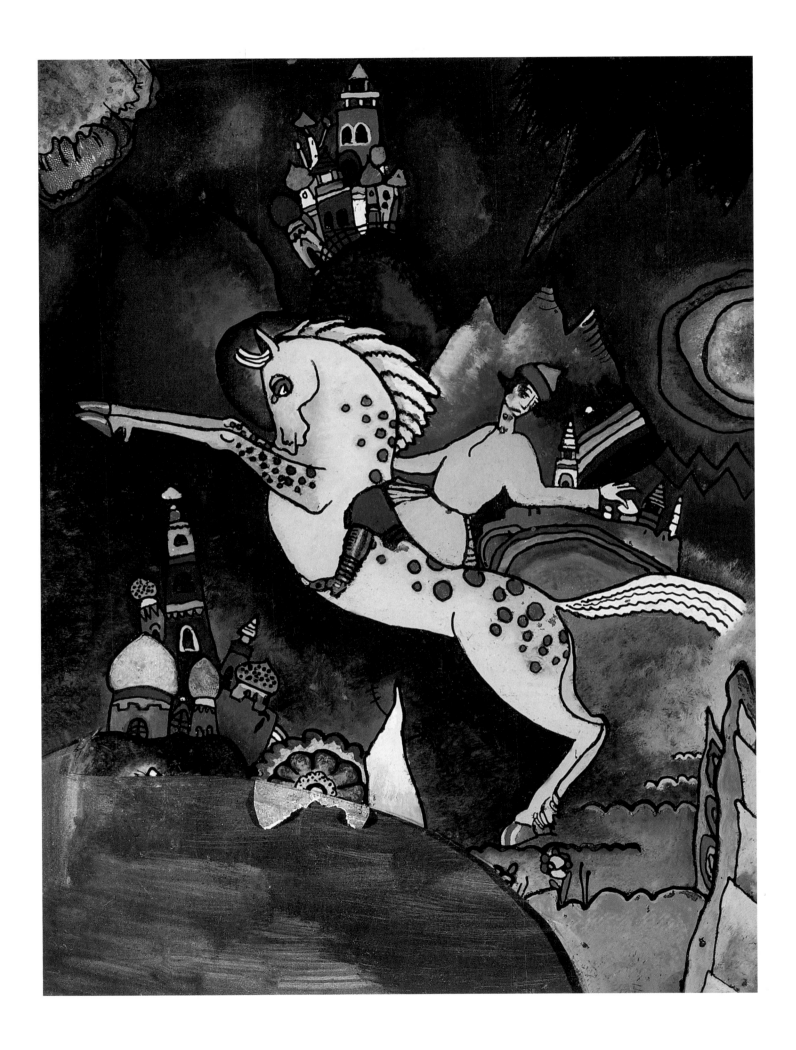

As perceived on a molecular level, the innermost secrets of a substance are realized in such stately rhythms that they are capable of turning into structures of a cosmic scale. In turn, however, the galaxy resembles a molecule: the infinitesimally small is just as inaccessible to the mind as the infinitely large, and in the final analysis they are identical to one another, as abstract categories.[32] A fish might be perceived as a tiny pond-dweller, it might be perceived as a dream or, even, a constellation. Or perhaps it might be seen as an image lacking any connection with the real world.

On the threshold of a new millennium, Kandinsky's worlds summon up associations with the problems of the beginning of this century, the problems out of which his art grew. These "depicted" emotions, this visible subconscious, approximate what would begin to emerge in the second half of the twentieth century. The planet in Stanislaw Lem's great novel *Solaris*, a mysterious substance capable of penetrating into the subconscious of beings from another civilization and sending them incarnations of their own memories, is an image that would never have entered into art, it would seem, were it not for Kandinsky (and Hesse, Klee, Mann, and Magritte). Intellectual science fiction, new musical rhythms that affect the listener's unconscious in a startling and unexpected manner, computerized "video art," a genre that is far from being understood and has so far been seen only in its most primitive forms — all these things would have appeared without Kandinsky's prolegomena. But it is likely that they would have appeared later, in a different form and a shabbier guise.

Unfortunately, we are not quite able to apply Wölfflin's[33] classical categories when we analyze abstract painting, while twentieth-century interpretations often strike us as ode-like and pretentious. But here Aristotle's ancient thesis (as stated in the *Poetics*) — in genuine works of art there are no voids, there is nothing superfluous, nothing can be added nor taken away, nor shows any sign of aging. This does not mean that all of Kandinsky's abstractions, especially the early ones, are examples of perfection. But it does allow us to appraise the best of these works.

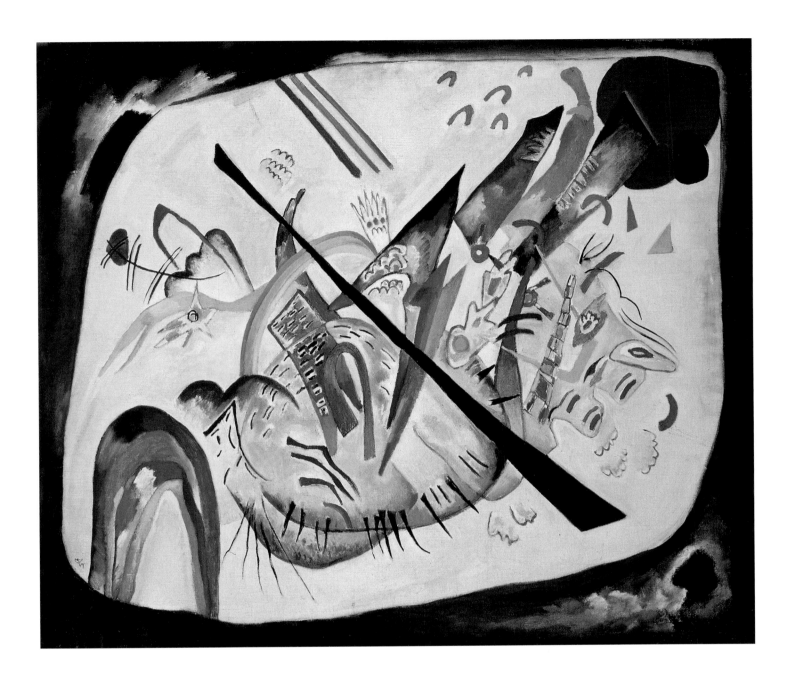

When, with the *Improvisations* and *Compositions* of the late 1910s, Kandinsky made his final break with the object world,[34] he preserved (until the early thirties) the feeling of dynamic, even organic, life in his paintings.

Would we be wholly justified in calling these works "nonfigurative"?

If in his Suprematist compositions Malevich strives to create a world void of warmth and passion, a world of harmonies unconnected with time and unencumbered by contradictions, then Kandinsky can be interpreted as his complete antipode. He neither conquers space nor submits to it: he creates something theoretically different.

White Oval, 1919.
Oil on canvas, 80 x 93 cm,
Tretyakow Gallery, Moscow.0:
Composition. Colors,
Tretyakow Gallery, Moscow.

Amazon, 1917.
Oil on canvas, 80 x 93,
Tretyakow Gallery, Moscow.

Amazon in the Mountains, 1918.
Glass-painting, 32 x 25 cm,
Russian Museum, St Petersburg.

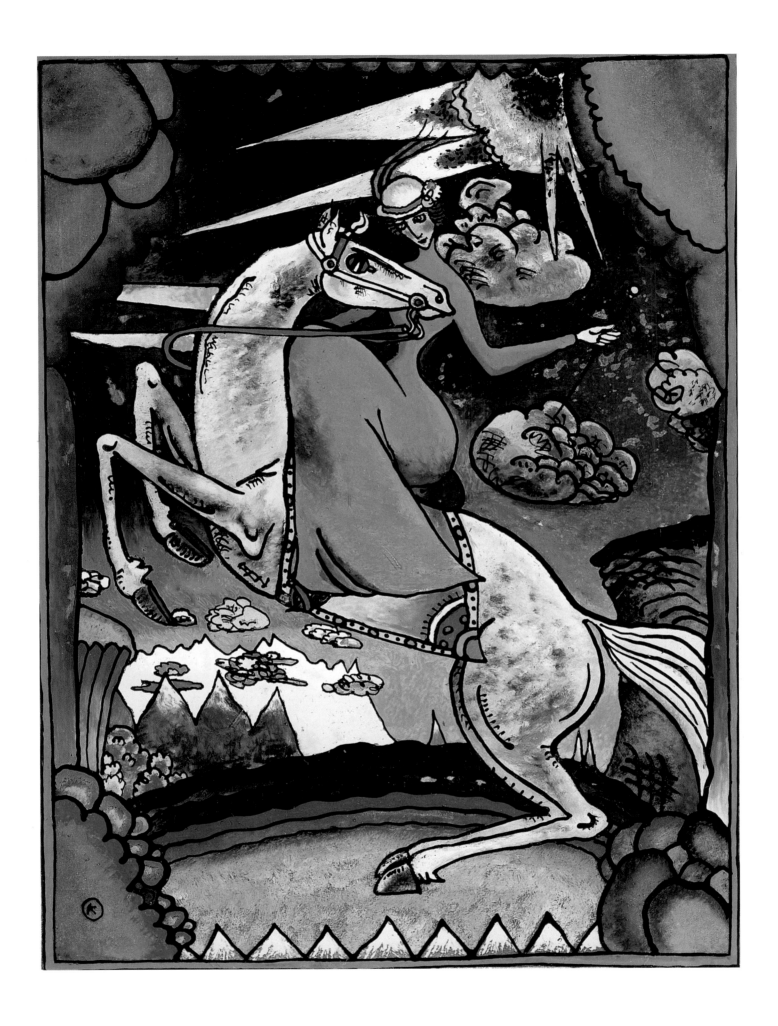

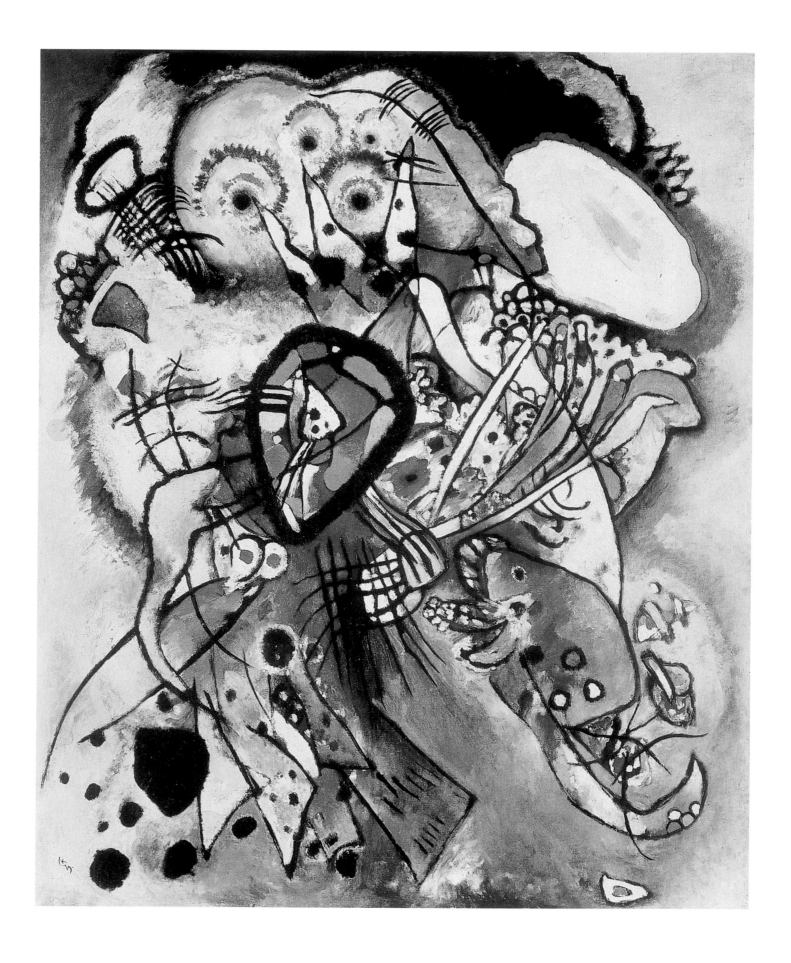

This "something" is not seen from without, but it does exist in consciousness and, therefore, is not subject to the usual system of coordinates. In consciousness, what is seen now and what was seen long ago, the imaginary and the known, what has been retained in memory and what is hazily recalled, the apparent and the real, all exist on equal terms, outside of time, without the sense of near or far.[35] But they are unfailingly in motion, in the process of becoming. And in proximity not simply to cosmism (Kandinsky's cosmism has already become almost a commonplace in art criticism), but likewise to that contemporary philosophical and fantasy literature in which such wholly scientific concepts as "quasar" and "black hole" have become dramatic metaphors. In Kandinsky's paintings, even the black anguished clots of darkness become festive and joyous explosions. The paintings cannot manage without these explosions, which purify consciousness; eschatological visions become emotional harbingers of change.

Take the famous canvas *Black Spot* (1912, Russian Museum): the doleful exultation of a golden space exploded by a dark and, at the same time, blinding flash, a flash that destroys any sense of peace, but likewise lends a dramatic equilibrium to the picture's formal structure. To borrow Thomas Mann's expression, a "visual acoustics" is created. Anxiety brings harmony to anxiety itself: this is akin to the psychoanalytical studies of the period, but isn't this natural?

In this picture one can detect without a doubt the dominance of the painterly principle over the linear, but spatiality vanishes insofar as the artist is gazing into the depths of consciousness. Instead of the usual coordinates depth, height, width — something similar to what Hesse called "the surplus dimension" appearsFormally speaking, the painting might serve as a canon of plastic and colorist equilibrium; but there is no peace in this world, the "freeze-frame" does not provide for immobility. As long as our eyes are focused on the picture, we believe in equilibrium: it is as if the process of contemplation maintains an unstable calm. Once the viewer turns away, the fever of consciousness destroys a mad world which had halted for a moment.

Two Ovals, 1919.
Oil on canvas, 107 x 89.5 cm,
Russian Museum, St Petersburg.

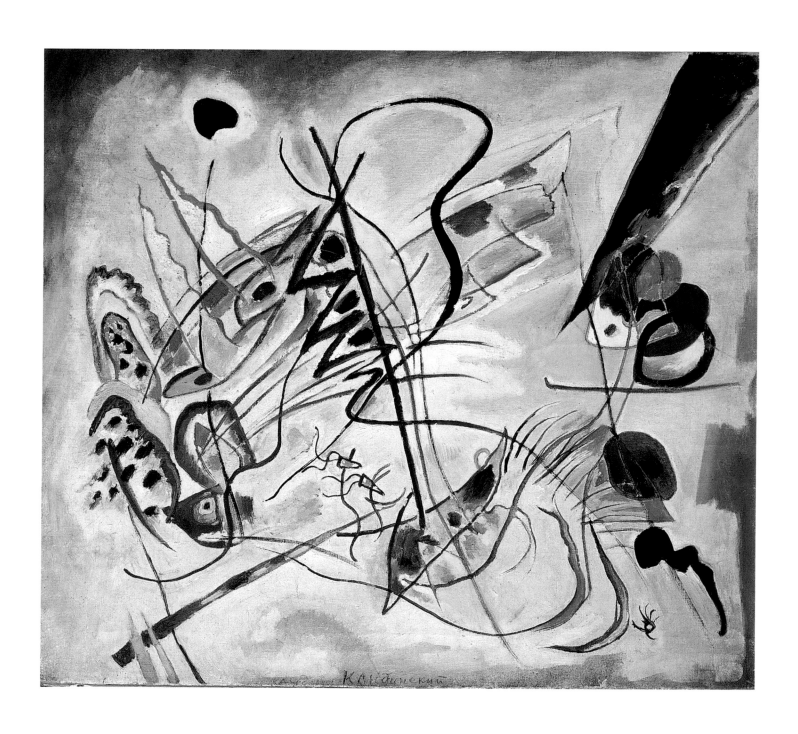

Musical Opening. Violet Arrow, 1919.
Oil on canvas, 60 x 67 cm,
Museum of Fine Arts, Toula.

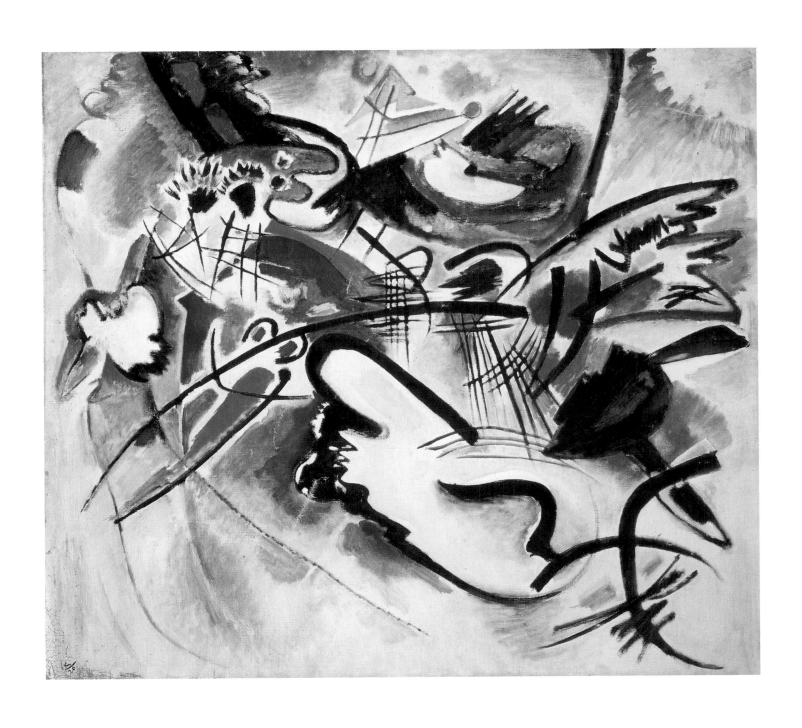

Composition. Red and Black, 1920.
Oil on canvas, 96 x 106 cm,
Museum of Fine Arts, Uzbekistan.

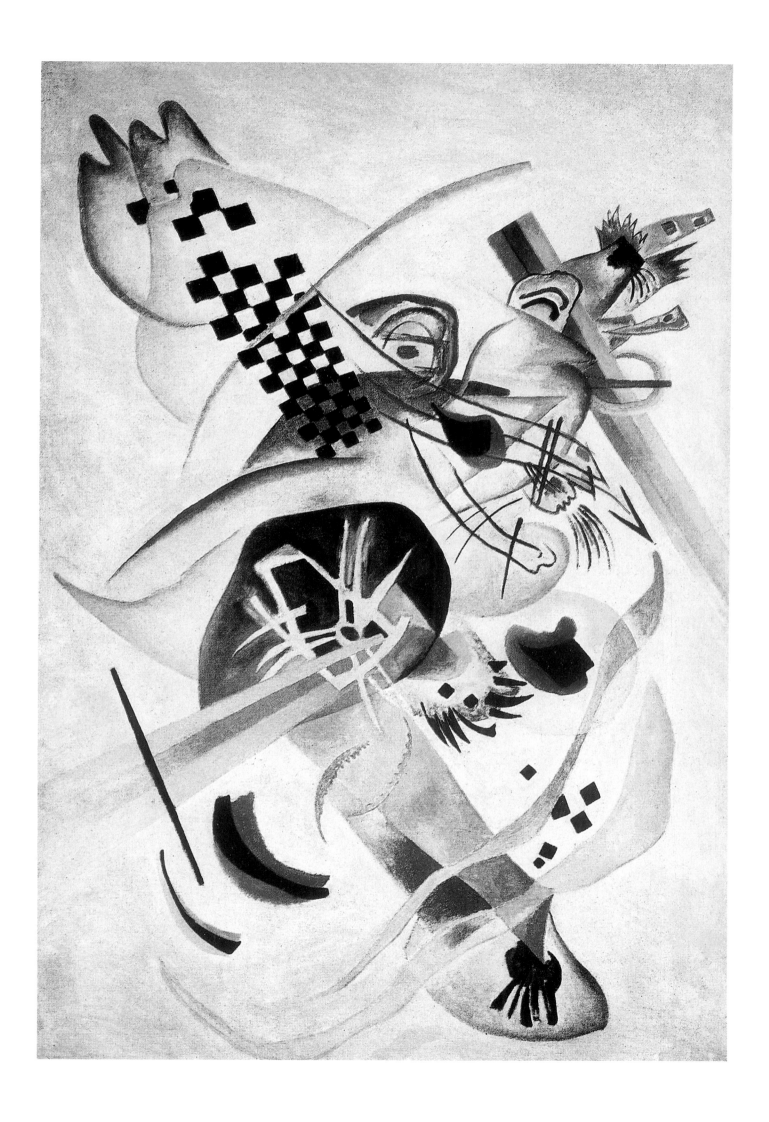

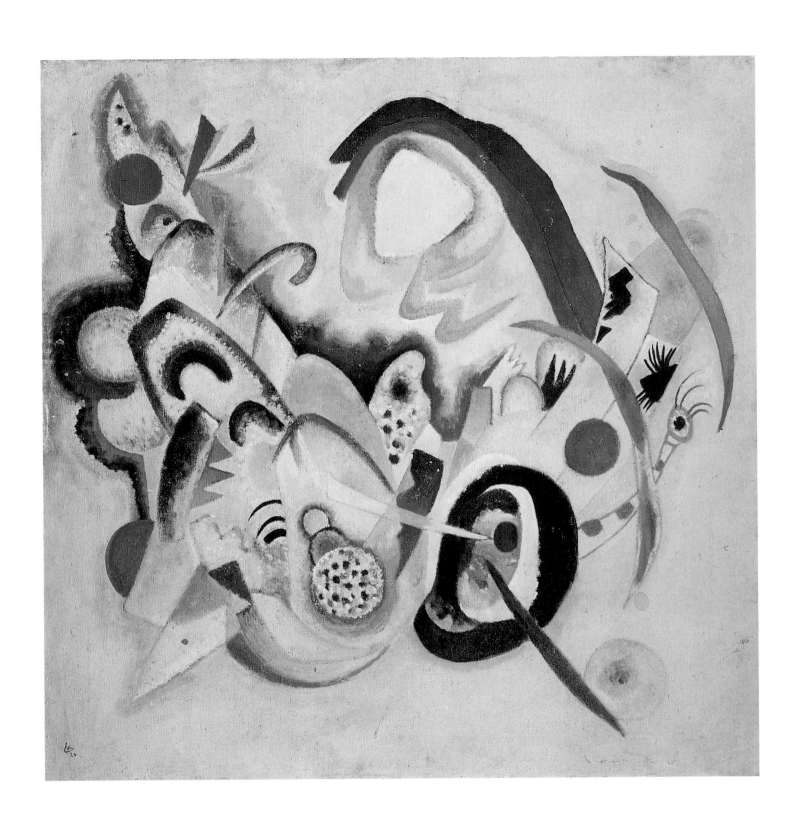

On White, 1920.
Oil on canvas, 95 x 138 cm,
Russian Museum, St Petersburg.

On Yellow, 1920.
Oil on canvas,
Museum of Fine Arts, Uzbekistan.

These works of Kandinsky are capable of relieving the troubled human soul of the burden of unconscious anxiety, an anxiety which no one is able to comprehend because it is devoid of those qualities which can be verbalized. Kandinsky's anxious visions, as if portraying and subtly estheticizing the phantoms of our unrealized passions, render them capable of explaining the inexplicable, of relieving man of the terror of loneliness and incomprehension: there is meaning, rhythm and harmony even in a frightening world.

> "Your gaze — let it be firm and clear.
> Erase the accidental traits —
> And you will see: the world is beautiful.
> Seek out the light and you will comprehend the dark."
>
> —Alexander Blok

It was hardly within the power of traditional art to "erase the accidental traits," for they are nothing other than those details of existence which give figurative art its life. But Kandinsky's paintings appeal directly to the depths of our spirits, bypassing those "gates of reason" that allow us to perceive any subject-based work of art.

On his canvasses worlds arise which science-fiction writers will still be a long time in conquering.

The passage from Blok cited above[36] is preceded by lines just as significant in their import:
> "But you, artist, must firmly believe
> In beginnings and ends. You must know
> Where heaven and hell guard us..."

The unity of beginning and end, of eternal renewal, of immortality, the proximity and indissolubility of heaven and hell: nowhere else in the art of that period did these things emerge as forcefully as in the work of Vasily Kandinsky. It is striking how naturally and profoundly his art harmonized with the image structure and problems of twentieth-century culture. Mann's plants in glass (glass — another strange association with Kandinsky's technique!), Blok's "beginnings and ends",

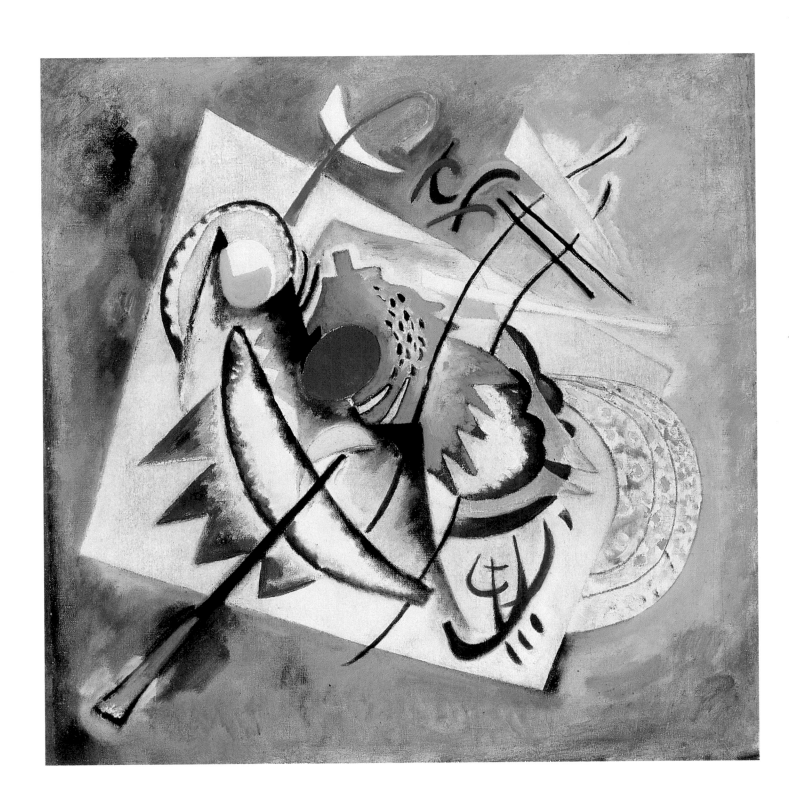

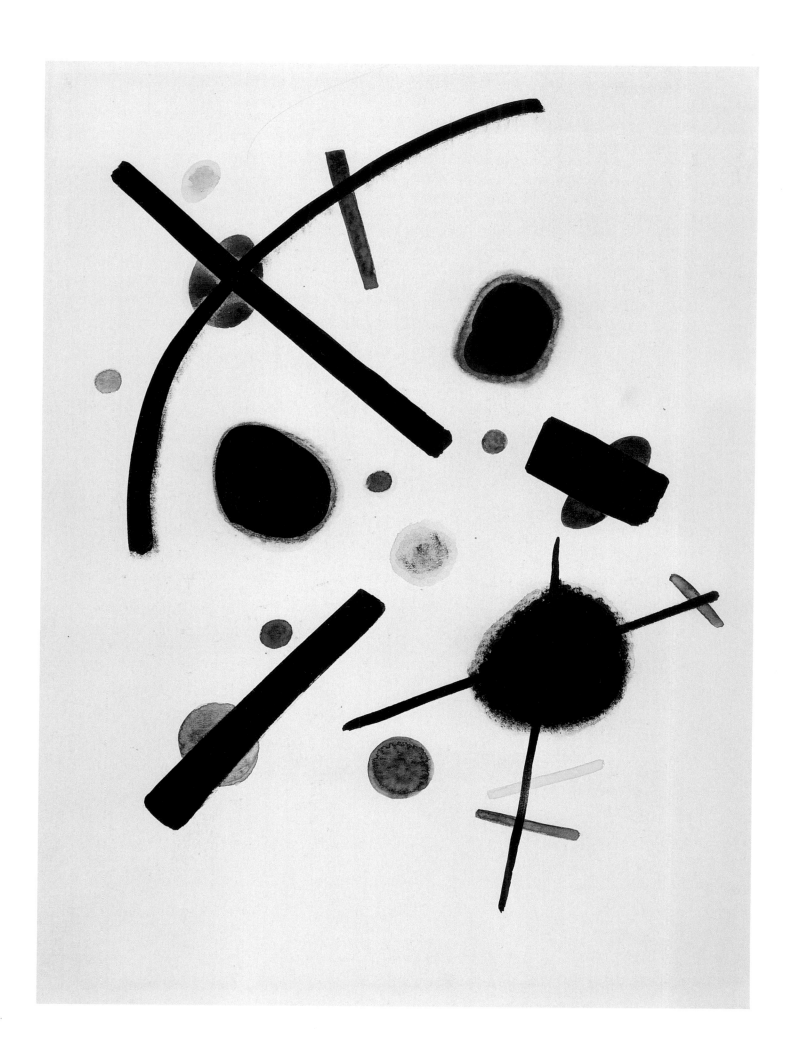

108

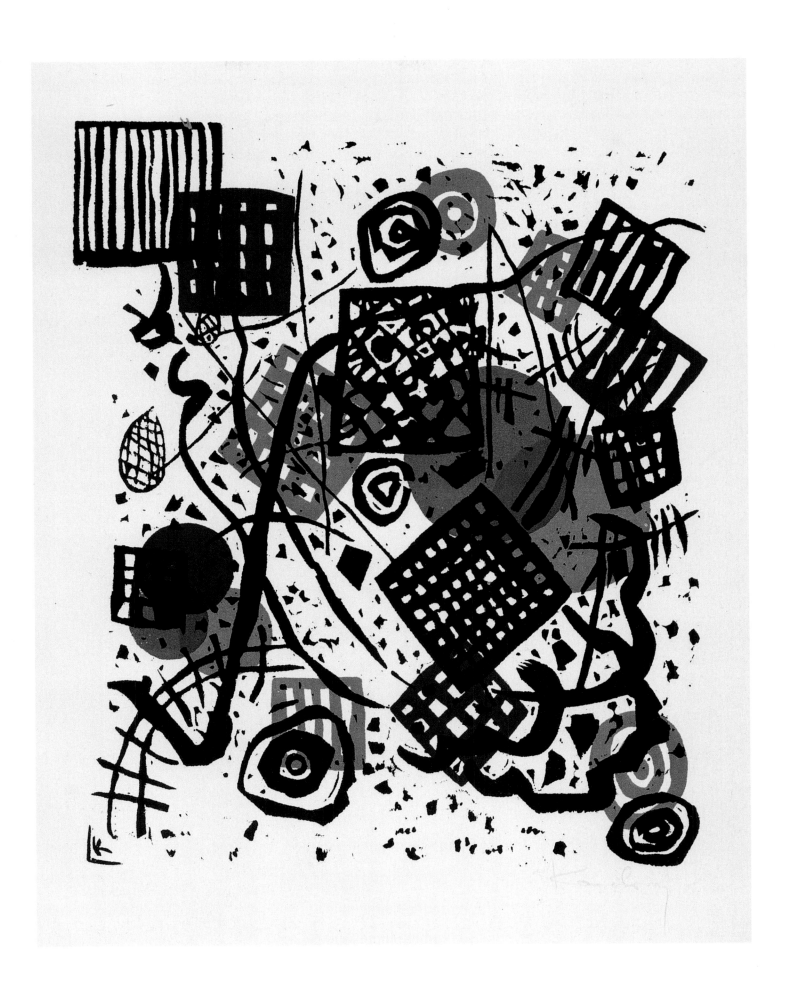

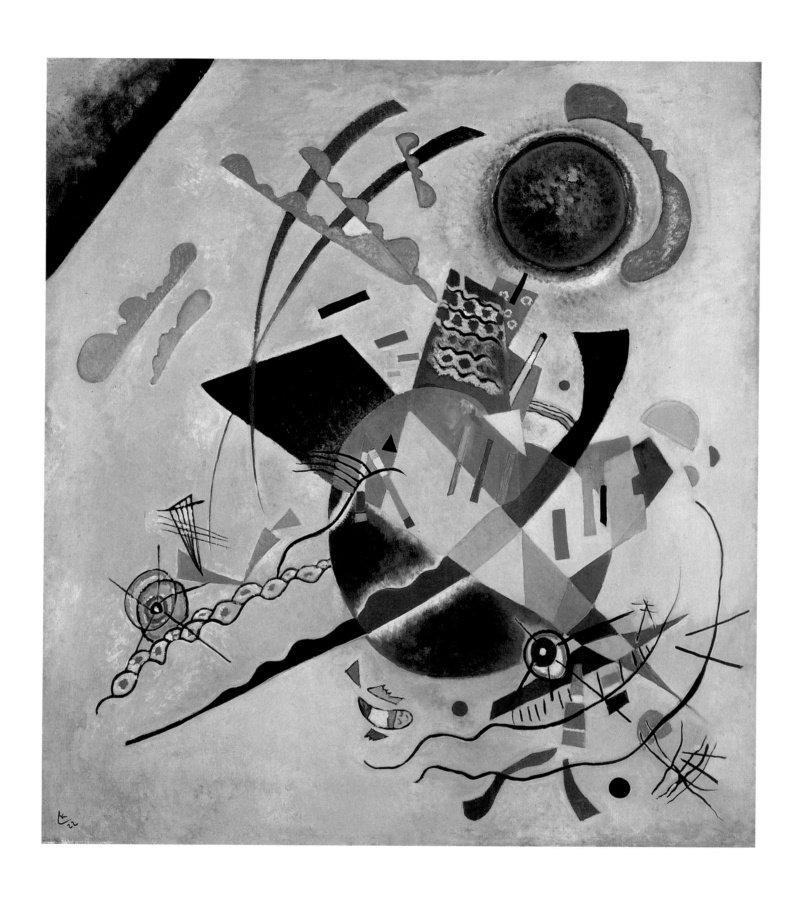

Blue Circle, 1922.
Oil on canvas, 110 x 100 cm,
Guggenheim Museum, New York.

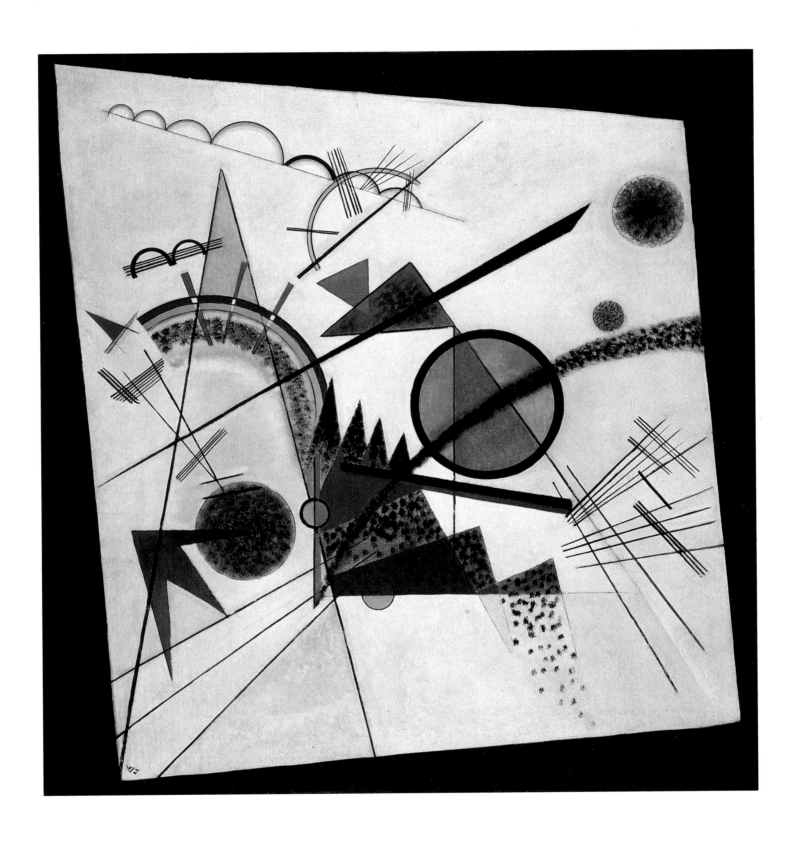

In a Black Square, 1923.
Oil on canvas, 97.5 x 98 cm,
Guggenheim Museum, New York.

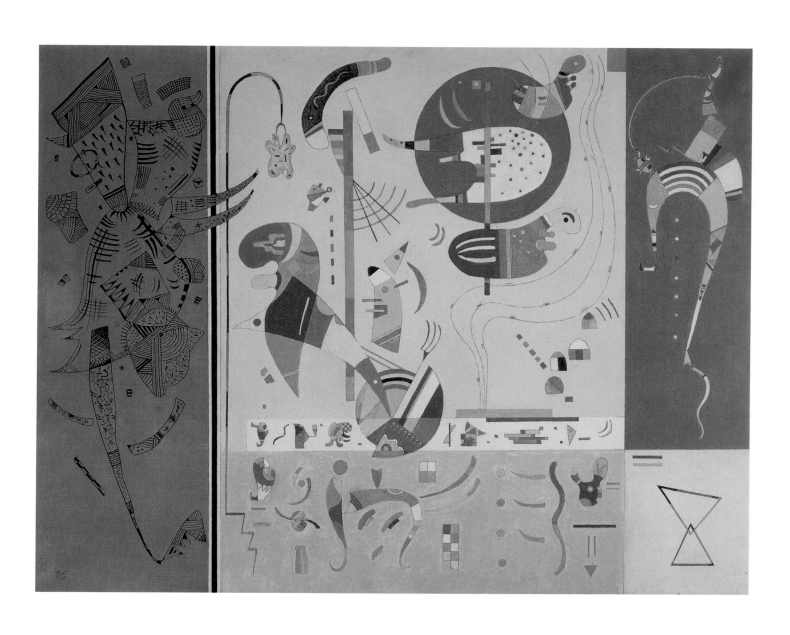

and the verses then yet to be written by one of Hesse's characters, verses entitled, like Kandinsky's book, "Steps."

The artist's authority was not based only on his best works and his artistic practice. The precise conclusiveness of his theoretical judgements, swathed in the aureole of his own vague and haughty poetic interpretations, provoked a fascinated attention similar to the enthusiastic success which greeted public appearances by the poets Konstantin Balmont and Igor Severianin. It would be unforgivably naive to place all of Kandinsky's written works, including the poems, in the same rank as his paintings.

Doubtless there is much in his texts, especially the poetic ones, which is rather a concession to the tastes of his time than the independent judgements of a strict intellect: "But that's not good at all, that you don't see the gloom: in the gloom is where it is." But alongside these are startling and timeless verses that anticipate, as it were, the theatre of the absurd.[37]

Not bothering to examine the nature of the political changes that were taking place in Russia at that time, Kandinsky quite willingly accepted a number of official posts in the newly-formed government organizations. He served as director of the Museum for Pictorial Culture and for a time he headed the monumental art section at INKHUK (Institute of Artistic Culture). His works were acquired by the state.

Like many other liberal-thinking members of the intelligentsia, he assumed that after deliverance from the moribund czarist regime, things would change for the better. But nothing changed for the better and, leaving for Germany in December 1921, he would never again return to Russia.

Six years earlier he had come to a Russia where a new and mighty avant-garde movement had arisen. He was leaving the Russian Soviet Federal Socialist Republic, where freedom in art was living out its final years.

Different Parts, 1940.
Oil on canvas, 89.2 x 116.3 cm,
Gabriele Münter and Johannes Eichner-Stiftung, Munich.

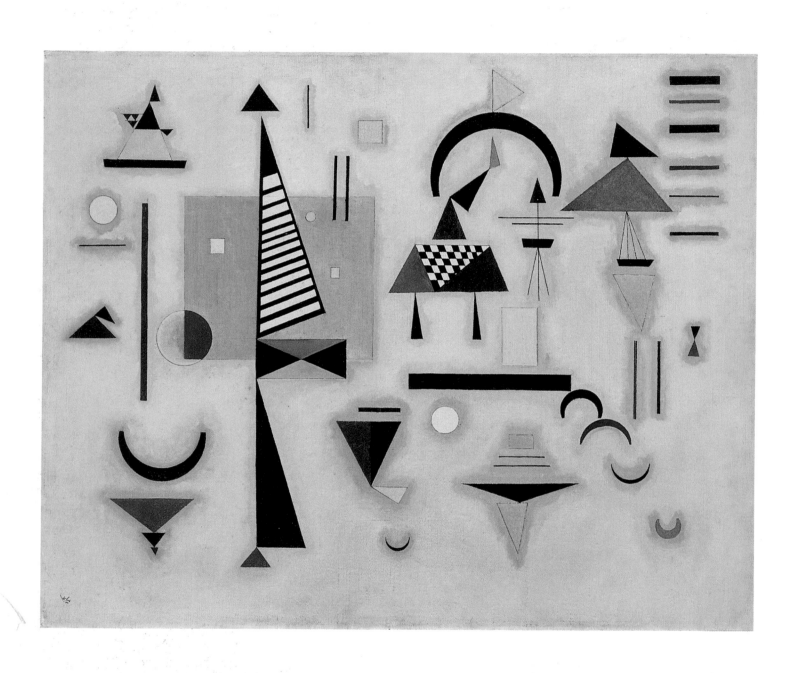

Decisive Pink, 1932.
Oil on canvas, 80.9 x 100 cm,
Guggenheim Museum, New York.

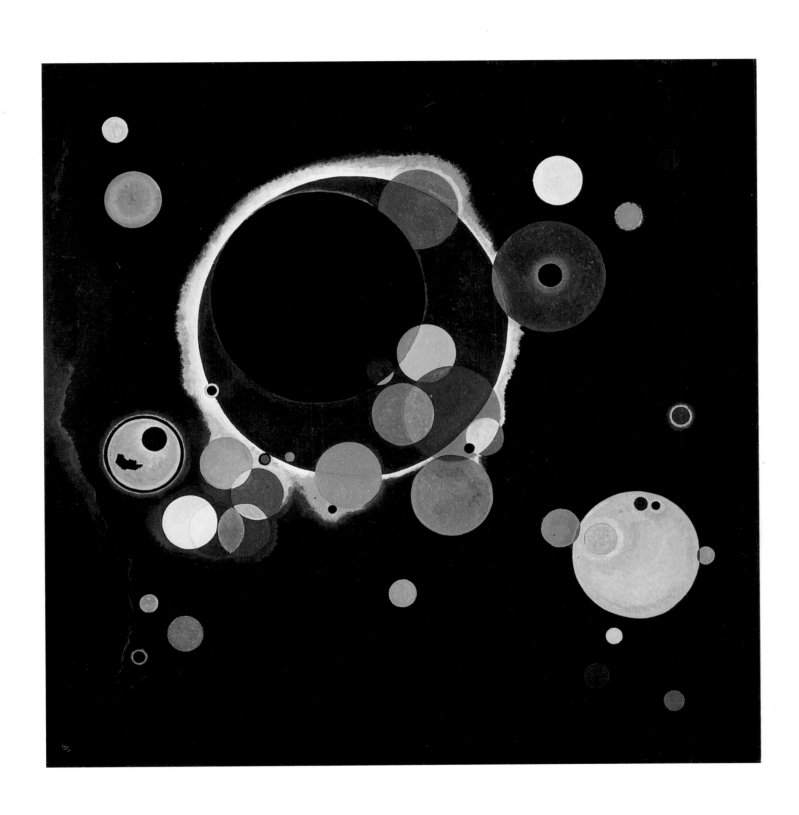

Several Circles, 1926.
Oil on canvas, 140.3 x 140.7 cm,
Guggenheim Museum, New York.

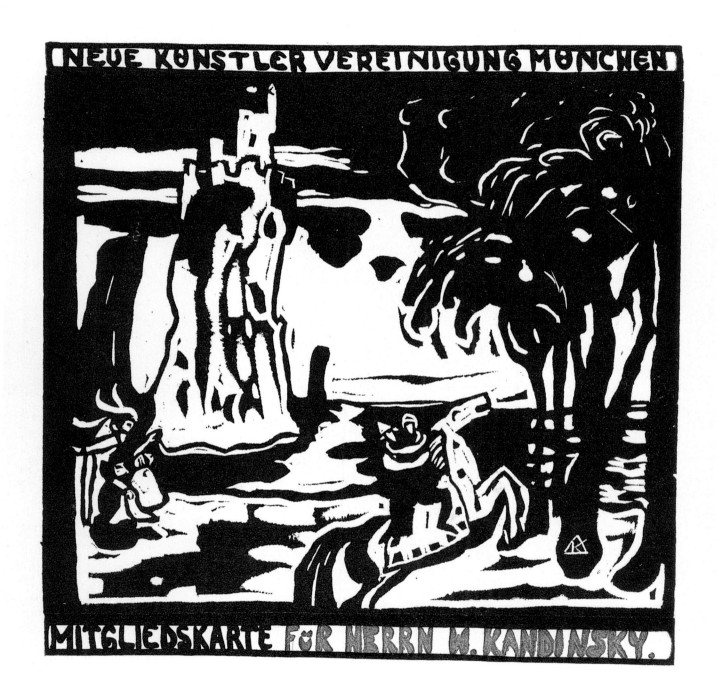

Scala.

Abstractions,
Engraving,
Tretyakow Gallery, Moscow.

116

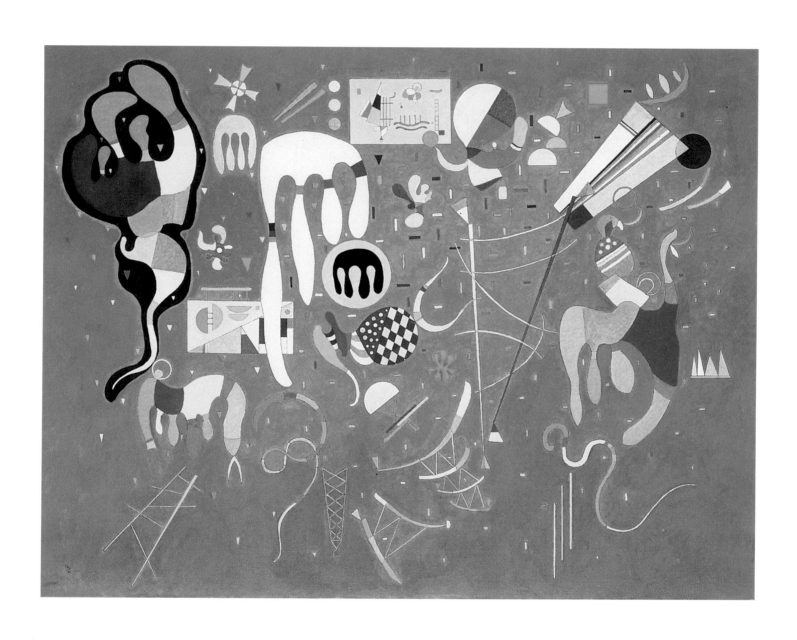

The Return

"There his last paintings were done, those free paraphrases on the forms of the world of phenomena, those strange, glowing, and yet dreamily tranquil pictures . . . "

–Hermann Hesse, *Klingsor's Last Summer*

In the summer of 1922, Kandinsky began teaching at the Weimar Bauhaus. Recalling this period, he writes that he felt indebted to his students.[38] This corroborates what we have already said about Kandinsky's having become a master from the very beginning through the instruction of others.

It is likely that for Kandinsky this was a time of complete self-realization, the feeling of being in the right place. Professional stability combined with the chance to teach gave him confidence that his theory was being heard by those he was making masters. At the Bauhaus he succeeded not only in pursuing the theory of monumental art, but in realizing his own massive designs with the help of his students: a situation reminiscent of Renaissance guild brotherhoods and one that naturally gave Kandinsky the particular sense of a total and profound interaction with the universe.

It was then, in the first Bauhaus years, that he began work on his *Worlds*, works in which he quite directly contrasted the grandeur of the great and the small. The *Worlds* were qualified as "small," and in this lay both their meaning and a paradox: by definition a world is something great, it is essentially everything.

Varied Actions, 1941.
Oil on canvas, 89.2 x 116.1 cm,
Guggenheim Museum, New York.

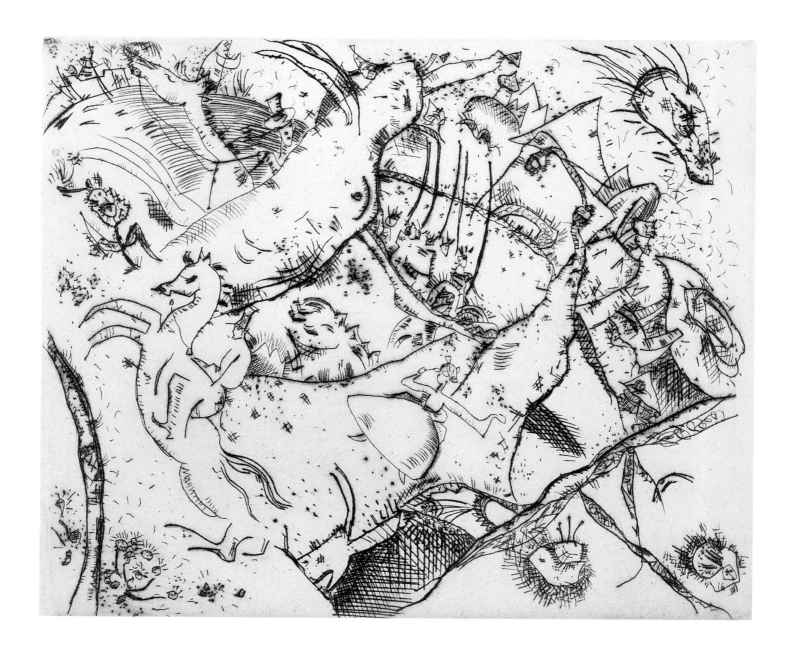

Engraving III, 1918.
13.5 x 16 cm,
Tretyakow Gallery, Moscow.

Composition. Untitled.
Tretyakow Gallery, Moscow.

And this everything is small?

"Yes," the artist answers. As it were, "it can be concentrated in an atom, in an atom's particles, for the consciousness of man is neither great nor small, and only in it do worlds have their existence."

The grandeur of the small (and the smallness of the great) is sharply felt in his graphic masterpiece *Small Worlds* (1922, Städtische Galerie im Lenbachhaus, Munich). In the twelve prints of this series (among which are color lithographs, woodcuts and etchings), the artist finds an unprecedented freedom in his technique and mastery. This work is, as it were, the focus of the artist's past experiments and current finds, real visions and pure abstraction, prints in which the

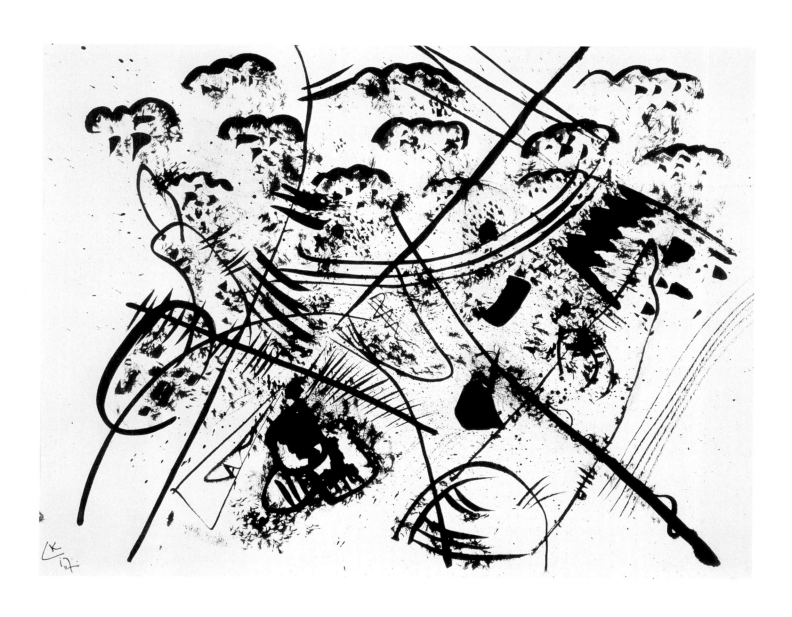

motifs of twentieth-century art intertwine and are even quoted, a parade of associations, a veritable "picture-gallery of the soul," an unprecedented instance of harmonic tension between the visible and the known.

When the hero in Chekhov's story *The Black Monk* doubts the reality of an apparition, the apparition's reply is stunning: "You can think as you like. . . I exist in your imagination, and your imagination is part of nature, so I exist in nature."[39]

Pragmatically and merrily assembling fragments of art past and art near at hand, the postmodernists have scarcely risen to the regal heights of *Small Worlds*, in which a noble refinement of technique brings to fruition (within a surprising and individual stylistic unity) an entire era of experiments — Kandinsky's own and those of his contemporaries. Seemingly dissimilar styles and techniques, aspects and degrees of reality, "visit" one another, engage in unhurried dialogue, listening to one another and becoming imbued with the rhythms of their interlocutors.

We might imagine that when, several years later, Kandinsky and Klee[40] moved into neighboring cottages, their discussions as they strolled the banks of the Elbe were likely reminiscent of both the debates of the Kastalian masters (in Hesse's *The Glass Bead Game*) and these astonishing *Small Worlds*, full of grandeur and tolerance.

Small Worlds reminds us not only of what Kandinsky had already accomplished, but of what he was still to accomplish. Thus, plate VII is already a step in the direction of the famous painting *Several Circles* (1926, Guggenheim Museum). Small universes absorb both art and secret notions of the great and the infinitesimally small, of the past and the future, of the possibility and inevitability within creative work itself of reconciling different times and conceptions of the beautiful.

In keeping with the *Small Worlds* are the studies for the mural painting of the Juryfreie exhibition in Berlin (1922, Musée National

Composition,
Private Collection.

123

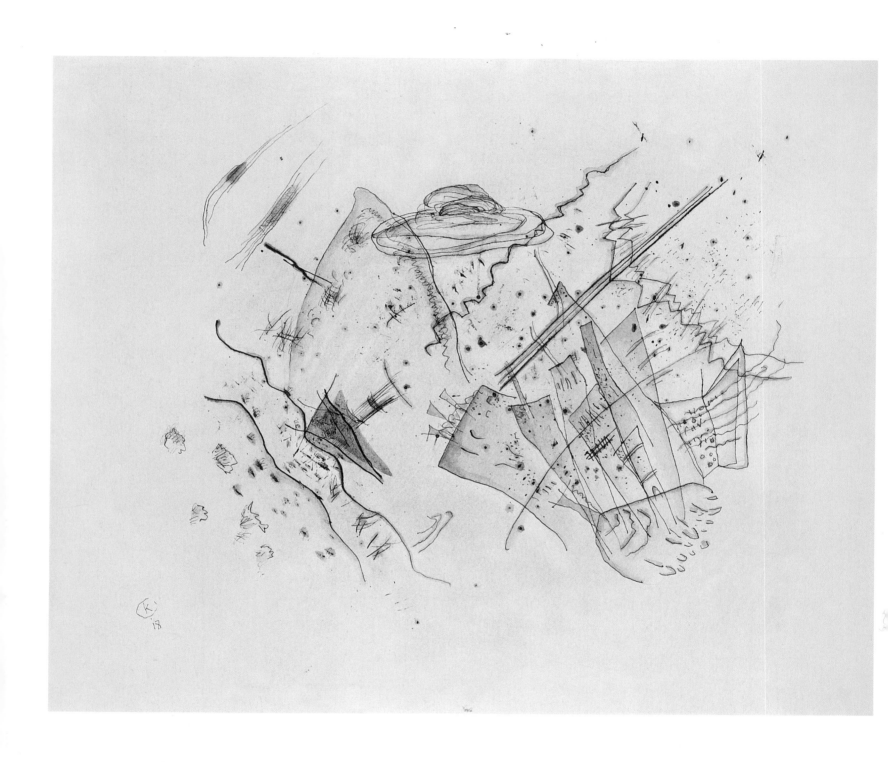

Composition. Color and Line.

Engraving IV, 1916.
39.9 x 29.8 cm,
Tretyakow Gallery, Moscow.

126

Abstract Composition,
Tretyakow Gallery, Moscow.

Composition. Lines and Colors.

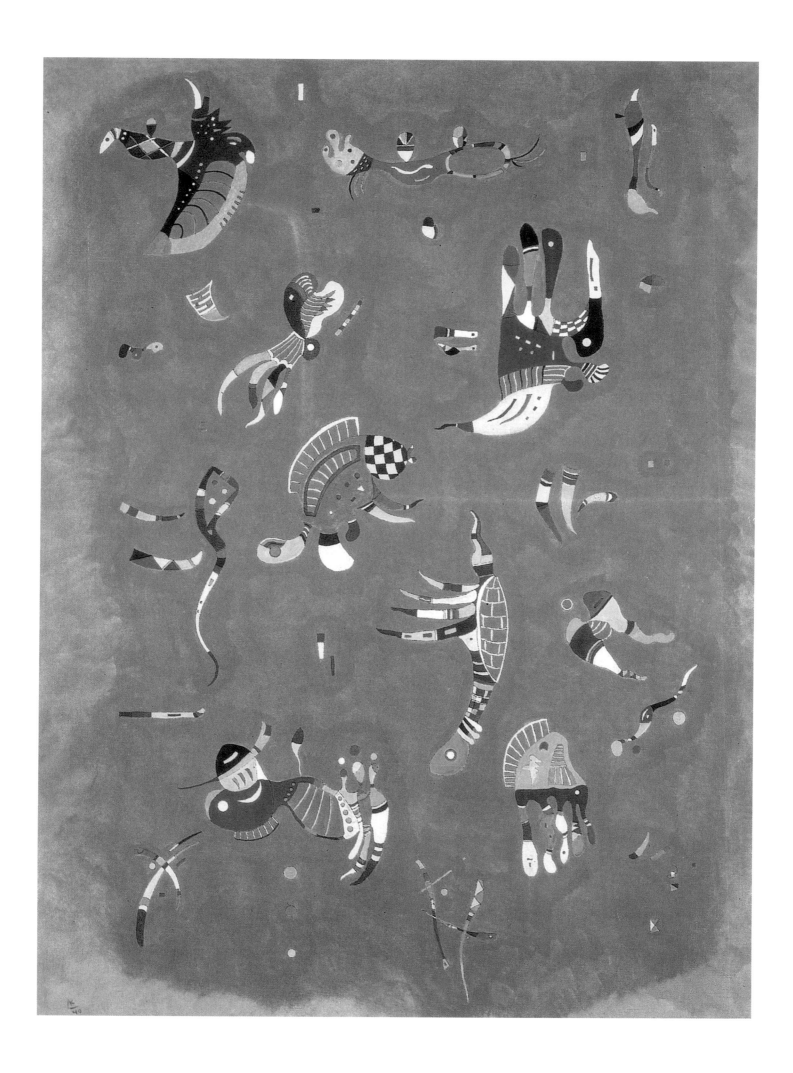

d'Art Moderne, Center Georges Pompidou, Paris). To some degree, these passionate but precisely calculated compositions seem a tribute to various tendencies within Kandinsky's own art, and to tendencies in modern art in general.

Here we find a crystallization of the planetary and zoomorphic myth so typical of Kandinsky (panel A), and almost geometrical compositions (panel C), and something reminiscent of Miró's experiments (panel D). "All roads which we traveled separately until today have become one road, which we travel together, whether we like or not," wrote Kandinsky in an exhibition catalogue.[41]

In these years Kandinsky's fame grew with that of the Bauhaus. In the school's essence there was much that was deeply congenial to the artist: merciless professionalism, a kind of romantic rationalism, intellectual refinement, laconism. It is likely that if there had been a school of applied arts in Kastalia, it would have resembled the Bauhaus.

Europe's artistic elite came to its exhibitions in Weimar and, later, in Dessau (to which the Bauhaus moved in 1925). Einstein, Chagall, Duchamp, Mondrian, Ozenfant and Stakovsky were among the guests of Kandinsky and the Bauhaus masters.

Kandinsky exhibited regularly and with success. His sixtieth birthday (1926) was marked with a massive retrospective exhibition in Braunschweig. In 1929 Solomon Guggenheim bought one of his paintings.

Kandinsky noted (1929) that non-figurative painting "continues to develop further towards a cold manner" and that for Surrealism (then in its developing stages), abstract form might seem "cold."[42] The artist himself determined the essence of what was happening to him in the context of his environment.

On the one hand, the presence of surrealistic overtones in his art is unquestionable. Those splendid carnivals of the subconscious, those "landscapes of the soul," realized in his simultaneously menacing and

Blue Heaven, 1940.
Oil on canvas, 100 x 73 cm,
Museum of Modern Art, Centre Georges
Pompidou, Paris.

Stencil Painting with Rider, ca 1910.
Oil and pencil on cardboard,
24.2 x 33 cm.

Untitled, 1915.
Pen and india ink on paper,
Museum of Fine Arts, Krasnodar.

130

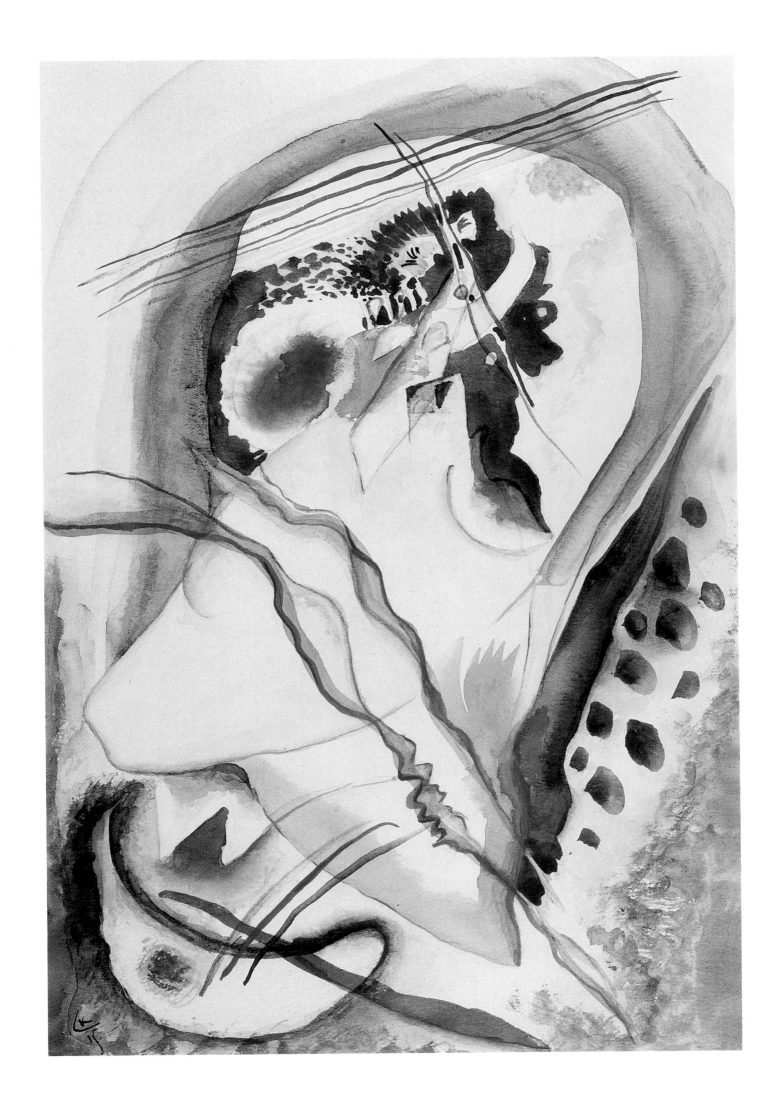

131

festive paintings from the 1910s, had already been a partial contact with the poetics of Surrealism.

On the other hand, with the passing of time, images consonant with the experiments of the Surrealists (who find the going tough in the chilly surroundings of Kandinsky's intellectual abstractions) are to be glimpsed fleetingly in his works.

Several Circles (1926, Guggenheim Museum) is an almost square canvas with a staggering feeling of universality, of that unity of the infinite and the small to which Kandinsky had so aspired.

We must once again recall the phrase of Hesse's we cited above:

"there is no top or bottom; these exist only in man's brain, which is the home of illusion." Kandinsky courageously equates "the home of illusion" with reality; he even makes the imagined world more stable, haughtily gazing down on the real vanity of the real world.

As if all the earlier "small worlds," the passionate explosions of the early abstract works, had abated, concealing in their cold depths the secret energy of dark suns.

A tense and bleak calm, bright, like a carnival, and strict, like one of Bach's fugues; an equilibrium triggered to fatally (though not yet imminently) explode — all of this is submerged in a time not at all commensurable with the brevity of human life, a time that has seemingly frozen forever. Here, it seems, is everything that Kandinsky, that generous wise man, wanted to say to his own age and to the future.

As is well known, the artist lived out the last years of his life in France, having left Germany when the Nazis came to power.

In Russia he had come to know himself as an artist: Russian motifs and sensations nourished his brush for a long time. In Germany he had become a professional and a great master, a transnational master.

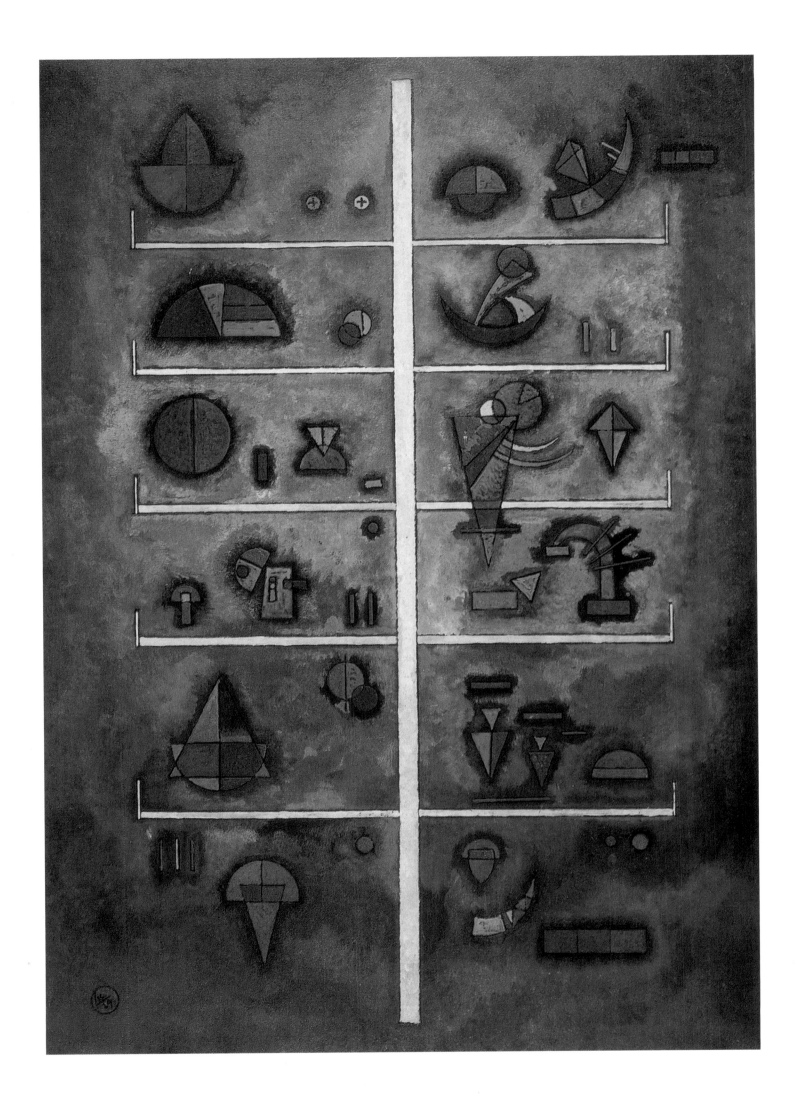

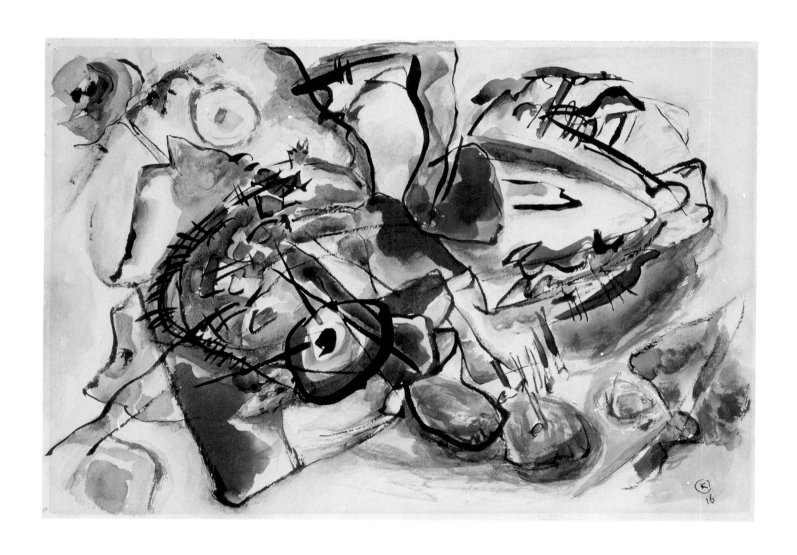

Aquarelle,
Tretyakow Gallery, Moscow.

Silhouette of a Woman.

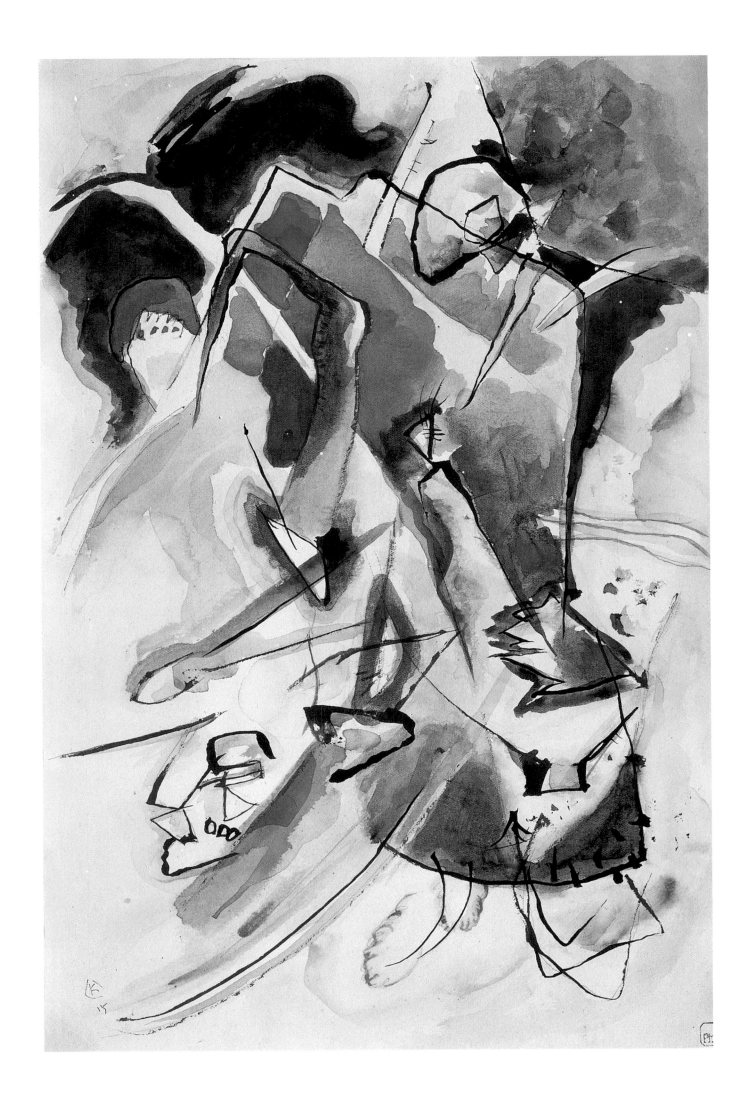

135

In France, where he was already welcomed as a world celebrity, he completed — brilliantly and a bit dryly — what he had begun in Russia and Germany. But there was a certain beautiful logic in the fact that, having left his two beloved countries when the darkness of totalitarianism threatened them, Kandinsky ended his days in France, which already long before had become a symbol of freedom in the arts and a place where the arts breathed most freely of all.

Perhaps it is true that, at the end of his career's trajectory, Kandinsky partly lost his originality, but it would be more accurate to say that it was not so much that he came to resemble other masters, as much as other artists were drawn into the "gravitational field" of his art. This process, however, was a reciprocal one: Kandinsky both took much from his own time and gave much back to it.

However much has been written or said about Kandinsky, however many times the weary consciousness of our century has attempted to make his name and art a commonplace in the history of modern culture, Kandinsky's worlds, large and small, have not become easy to understand. These worlds enchant, sometimes they nonplus; but, as before, they conceal a multitude of strange enigmas.

Take the famous painting *Thirteen Squares* (1930, Musée National d'Art Moderne, Georges Pompidou Center, Paris). Variegated squares — now viscous, opaque and heavy, now tenderly translucent, now shedding their own radiance — swim slowly in a foggy mirage like unburdensome, but serious, thoughts.

They form their own small (or gigantic?) world, just as every man — a molecule of the universe — is also an entire universe. They swim, gladdening and troubling us, asking riddles and helping to guess the meaning of life. Again and again reminding us that, in the words of the poet Nikolai Gumilyov, "our world has not been discovered in its entirety . . . "

Observations about the Theory of Colors and sketches, ca 1930.
27.5 x 21.1 cm.

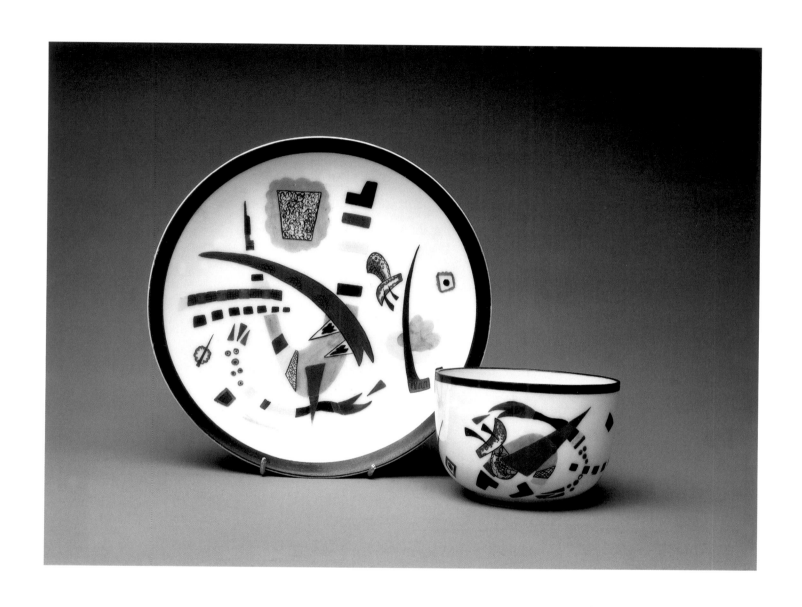

The "Blaue Reiter": A Look Back

"It was then that my desire to put together a book (or almanac) to which only artists would contribute was ripening. Most of all, I dreamt about painters and musicians. The pernicious isolation of one art from another, of "art" from folk and children's art, from "ethnography," the firm walls that had been raised between (in my opinion) such kindred, often identical, phenomena — in a word, between synthetic relationships — gave me no peace. Nowadays it might seem strange how long I was unable to find a collaborator, funds — even just sufficient interest — for my idea. . . . Atonal music and its master, Arnold Schöenberg, then the ubiquitous object of catcalls, angered the public no less than . . . the isms in painting.

I met Schöenberg then and immediately found an enthusiastic supporter of the Blaue Reiter idea in him. . . . I already had connections with several of the future authors. This was the future Blaue Reiter, but as yet without any prospects for incarnation. And then Franz Marc of Sindelsdorf came to me. One conversation sufficed: we completely understood one another. In this unforgettable man I had found something quite rare for that time (and isn't it just as rare today?) — an artist who saw far beyond the limits of his own narrow circle, an artist who — not outwardly, but inwardly — set himself against restrictive and hindering traditions. I have Franz Marc to thank for the publication of *Spiritual* by the Piper Verlag: he paved the way. Long days, evenings, sometimes even nights, we discussed our line of action. From the very outset it was clear to us that we should act in a strictly dictatorial manner: full freedom for realizing the embodied idea. Franz Marc brought in useful help in the person of August Macke, who then was still quite young. We gave him the task of collecting ethnographic material, and we ourselves took part in this. He did a brilliant job and was given one more task — to write an article about

Cup with Saucer, ca 1920.
Painted by Kandinsky,
State Porcelain Factory, St Petersburg,
Private Collection.

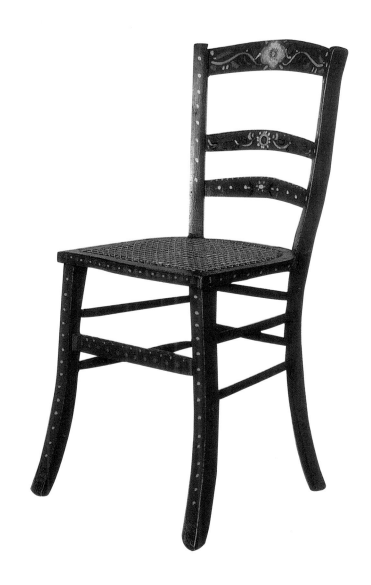

masks — which he performed just as beautifully. I gathered the Russians (painters, composers, theoreticians) and translated their articles. . . . (We thought up the name "Blaue Reiter" while sitting over coffee in a garden arbor at Sindelsdorf. Both of us were fond of blue things, Marc of blue horses, and I of blue riders. And Frau Maria Marc's fantastic coffee was even more to our taste.). . .

I hasten to mention as well Franz Marc's very generous patron, Bernard Kohler, who died not long ago. Without his helping hand, the Blaue Reiter would have remained a beautiful utopia, like Herwarth Walden's 'Erster deutscher Herbstsalon' (First German Autumn Salon) and other projects a well."

Vasily Kandinsky

Chair, ca 1910.
Decorated by Kandinsky,
85 x 41 x 37.5 cm.

Writing-table, ca 1910.
Decorated by Kandinsky,
80 x 89.2 x 60 cm.

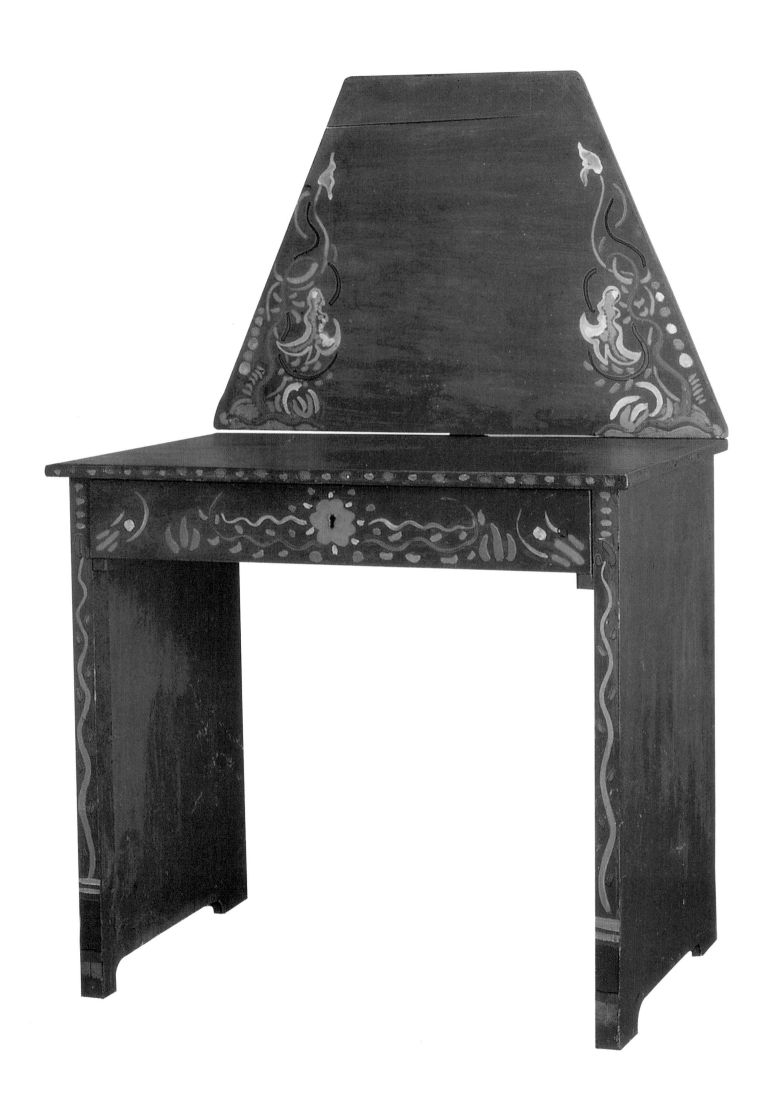

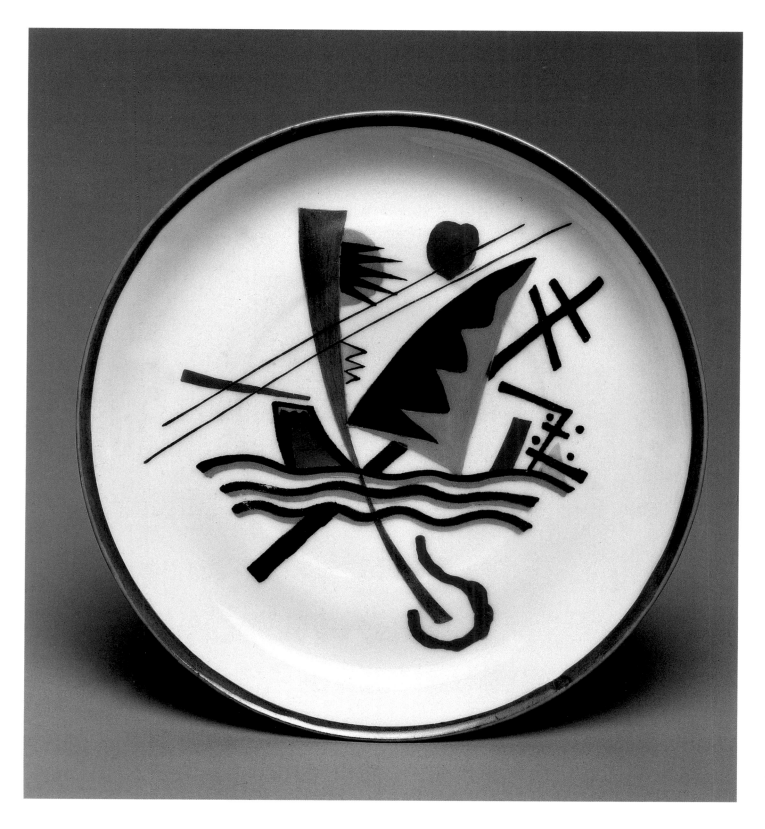

Page142:
Dish painted by Kandinsky.

Page 143:
Dish painted by Kandinsky.

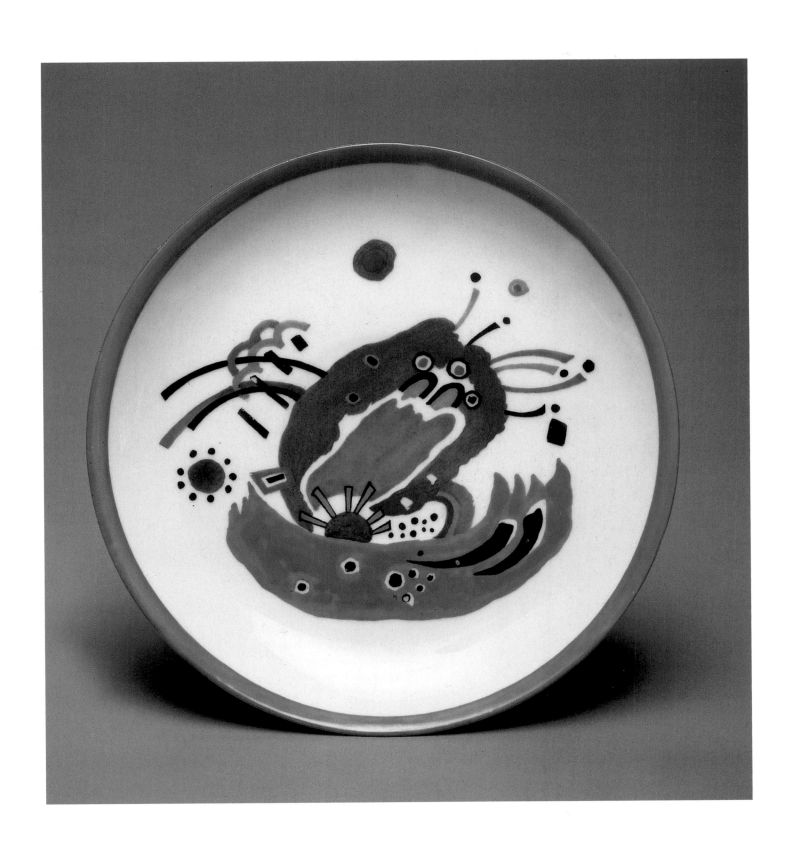

Page 145:
Composition. Untitled.
Tretyakow Gallery, Moscow.

Notes

1. All citations from Hesse's *Klingsor's Last Summer* have been taken from: Hermann Hesse, *Klingsor's Last Summer*, tr. Richard and Clara Winston, NY: 1970.

2. Kandinsky's maternal grandmother was German. "In childhood I spoke German a lot." (V. V. Kandinskii, Stupeni. Tekst khudonizhka, Moscow, 1918, p.10.) True, Grabar recalls that in the first years at the Azbé School he noticed that Kandinsky's "pronunciation of German phrases [was] unmistakably Russian." (Grabar, I.E., Pis'ma 1891-1917, Moscow, 1974, p.88.) In a university document a "fundamental acquaintance with three modern languages" was noted. ("Pis'ma V. V. Kandinskii k A. I. Chuprovu," ed. S. V Shumikhin, in Pamiatniki kul'tury. Novye otkrytiia. Ezhegodnik 1981, St Petersburg, 1983, p.339.)

3. D. V. Sarabyanov holds that in this painting Kandinsky's work "is indistinguishable" from that of the members of the Moscow Association of Artists (at whose exhibition this painting was displayed). All the considerations stated above and, of course, our current knowledge of context allow one to detect in *Odessa — Port* a portent of the future. (D. V. Sarabyanov, E. B. Avtonomova, *Kandinskii*, Moscow, 1994, p.7.)

4. V. V. Kandinskii, op. cit., p.10.

5. Vasily Kandinsky, *Sounds*, tr. Elizabeth R. Napier, New Haven, 1981, p.47.

6. Grabar, p.88.

7. "But the longer I conversed with his [Stuck's] works," recalled Petrov-Vodkin, "the greater the impression of petrified immobility they conveyed on me: their bas-relief, one-eyed like a photograph, impeded their being lifelike: you go out into the street and relax, and it's as if you screw your eye out of a one-sided viewing. After this, 'War' just seemed frightening to me — and, of course, for reasons quite other than those of a military nature. Stuck's pupils said that their art was reviving the art of the Hellenes — 'No, excuse me, in that case I'm prepared to defend Praxiteles and Phidias in hand-to-hand combat,' I objected with my characteristic passion." (K. S. Petrov-Vodkin, Khlynovsk. Prostranstvo Evklida. Samarkandiia, St Petersburg, 1970, p.398.)

8. V. V. Kandinskii, Stupeni, p.27.

9. Sarabyanov, Avtonomova, p.8.

10. It is worth noting that *Brand* was written in the year of Kandinsky's birth (1866), while *Peer Gynt* was written a year later.

11. Peg Weiss, *Kandinsky in Munich. The Formative Jugendstil Years*, Princeton, 1979, p.64. This period was also marked by his meeting (and subsequent romance with) Gabriele Münter, who for many years after would be Kandinsky's companion and confidante.

12. Kandinskii, op. cit., p.25.

13. "A queer thing is a mirror; a picture frame that holds hundreds of different pictures, all vivid and all vanished for ever." "The Mirror of the Magistrate," in G. K. Chesterton, *Father Brown*, Ware (Hertfordshire), 1976, p.226.

14. We have in mind here not only *The Double*, but also the story *Mister Prokharchin*, which in part replicates the motifs of the former.

15. Cf. B. Sokolov, "Kontrapunkt Velikogo Zavtra," Voprosy iskusstvoznaniia, X (1/97), p.399.

16. Hermann Hesse, *Steppenwolf*, tr. Basil Creighton, rev. by Walter Sorell, Hammondsworth, 1970, p.168.

17. This is discussed directly in a special postscript to the novel. Of course the most important similarity is the inner tragic unity of the artistic lives of Adrian Leverkühn and Arnold Schöenberg (1874-1951).

18. Marcel Proust, *In Search of Lost Time*, Vol. 1: Swann's Way, tr. C. K. Scott Monorieff and Terence Kilmartin, revised by D. J. Enright, New York, 1992, p.64.

19. Herbert Read, *Icon and Idea*, Cambridge, 1955, p.130.

20. Robert Delaunay, *Du cubisme à l'art abstrait*, documents inédits, ed. P. Francastel, Paris, 1957, p.96.

21. "I want as well to avoid going to Petersburg, even if this isn't very reasonable." (From a letter to Gabriele Münter, dated 15 October 1912, in Sarabyanov and Avtonomova, op. cit., p.133.)

22. Nikolai Kulbin read a short version of this work at the All-Russia Congress of Artists in late December of 1911. The atmosphere at this congress was quite tolerant and democratic: papers were read by Repin, Mate and others.

23. This exhibition was organized by the Odessa sculptor Vladimir Izdebsky, a member of the Neue Künstlervereinigung München, whose president Kandinsky was until 1911.

24. The explorations Lentulov made in the early years of this century, which were very similar to those made by Kandinsky during the Murnau period (although not nearly as powerful and profound), could not have failed to attract Kandinsky. The similarity of their aspirations was to become especially apparent later on see, for example, Gurzuf (1913, S. Shuster collection, St. Petersburg).

25. From a personal letter, cited in Vivian Endicott Barnett, *Kandinsky and Sweden*, (catalog) Malmö, Konsthall, p.45.

26. Cézanne made use of a partly similar process. In this sense, Kandinsky's Moscow cityscapes might be compared with Albert Marquet's post-Fauvist paintings.

27. Kandinsky himself warned against identifying nonfigurative art with music. (Cornelis Doelman, *Vasily Kandinsky*, Berlin, 1964, p.75.)

28. Thomas M. Messer, "Vasily Kandinsky," in *Vasily Kandinsky*, Haus der Kunst, Munich, 1976, p.41.

29. The reader should remember that when Kandinsky was young, it was the paintings of the Impressionists, an art distanced from figurativeness, which caused him to take a fresh look at the Russian icon. (Vasily Kandinsky, *Essays über Kunst und Künstler*, p.203.)

30. Leo Tolstoy, *War and Peace*, tr. Constance Garnett, New York, 1994, p.510.

31. This has been analyzed in detail by D. V. Sarabyanov (Sarabyanov, Avtonomova, op. cit., p.69). The author of this essay had also addressed the same problem (in a newspaper publication) as early as 1989.

32. Velimir Khlebnikov expressed similar ideas with reference to Malevich. Cf. E. F. Kovtun, "Put' Malevicha," in Kazimir Malevich, St Petersburg; Moscow; Amsterdam, 1988, p.159.

33. Heinrich Wölfflin (1864-1945), Swiss artist and art historian, author of Principles of Art History and Classic Art.

34. At the same time, Kandinsky continued to create wholly figurative works on glass, realizing fairytale and symbolist motifs in the specific forms of a laconic and "lubok"-like modernism.

35. Which, by the way, is characteristic of icons.

36. It is worth noting that the poem *Retribution*, the source of these citations, was written by Alexander Blok in the years 1910 — 1921, precisely the same period in which Kandinsky was developing his non-figurative art.

37. Cf. the poems *Seeing* (from which the above-cited line is taken) and *Why* in Kandinsky's *Sounds*.

38. Will Grohmann, *Vasily Kandinsky. Life and Work*, New York, 1958, p.175.

39. Anton Chekhov, "The Black Monk," in *Longer Stories from the Last Decade*, tr. Constance Garrett, New York, 1993, p.284.

40. In 1924 Kandinsky, Klee, Jawlensky, and Lyonel Feininger formed the group "Die Blaue Vier" (the Blue Four).

41. Grohmann, op. cit., p.174.

42. Vivian Endicott Barnett, *Kandinsky at the Guggenheim*, New York, 1983, p.46.

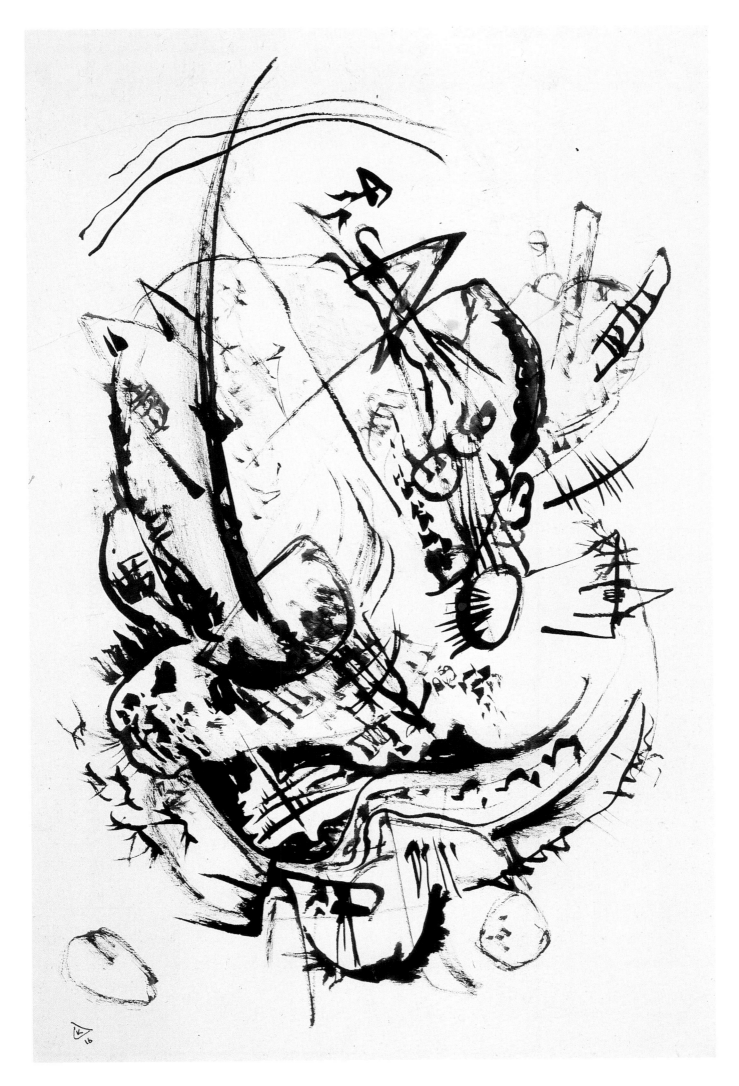

Vasily Kandinsky is born in Moscow on December 4, 1866, to the family of a tea merchant. After the family's move to Odessa and the divorce of his parents, his aunt assumes responsibility for the five-year-old Kandinsky's upbringing.

Until 1885 he attends a gymnasium in Odessa, where he studies drawing and music. He then enrolls in the Law and Economics departments of the University of Moscow.

Soon after completing his university studies, he marries his cousin, Ania Chimiakin. Although he becomes more and more interested in art, he accepts a position as a lecturer at the University of Moscow and writes a dissertation on the legality of laborers' wages.

In 1896 he moves to Munich, where he studies life drawing in Anton Azbè's private art school. It is there that he meets Marianne Werefkin and Alexei Jawlensky.

In 1900 he becomes a student of Franz Stuck, then considered the best draughtsman in Germany.

In May 1901 Kandinsky and his colleagues found the Phalanx artists' group, which soon opens its own drawing school.

In 1902 he meets Gabriele Münter, a student at the school. He spends time with his drawing class in Kochel, in the Bavarian Alps.

Under Kandinsky's leadership, Phalanx organizes twelve exhibitions in the period 1901-1904. The works of Phalanx members are displayed at these exhibitions, as well as works by representatives of the newest international art movements — Art Nouveau, Symbolism and Impressionism. Aside from his organizational responsibilities, Kandinsky studies art theory. He publishes numerous critical articles, primarily in the Russian journals *Apollon* (Apollo) and *Mir iskusstva* (The World of Art).

In 1904 Phalanx disbands, having failed to achieve its stated goal of providing non-academically inclined artists the chance to exhibit their works. In this same year, Kandinsky and his wife Anna separate. He begins living with Gabriele Münter, traveling with her a great deal. He divides his time between France and Russia.

In 1904 he exhibits for the first time at the Salon d'Automne in Paris (he continues to exhibit there until 1910).

In 1905 he participates in an exhibition of the Moscow Artists' Association. Therewith follow exhibitions with Die Brücke (the Bridge) in Dresden, at the Berlin Secession (1906), the Musée du Peuple in Angers (1907) and the Salon des Indépendants in Paris (1908). For an extended period Kandinsky and Münter live exclusively in Sèvres and Paris (1906-1907), and in Berlin (1907-1908).

In 1908 Kandinsky spends his first summer in Murnau, with Werefkin and Jawlensky. They buy a house, whose interiors Kandinsky designs.

The founding in 1909 of Neue Künstlervereinigung München (New Artists' Association of Munich), with Kandinsky named its chairman, marks a new stage in his active involvement in artistic life. This reaches its apex in 1909: the ünstlervereinigung's second exhibition is held, with many of the most prominent representatives of various international movements demonstrating their works.

Kandinsky spends autumn and winter of that year in Russia, where he exhibits fifty-two works at the "International" Salon in Odessa and participates in an exhibition of the Knave of Diamonds group.

In 1911 Kandinsky breaks with the Künstlervereinigung. His resignation is provoked by publication of *Protest Deutscher Künstler (Protest of German Artists)*, written by the Worpswede artist Carl Vinnen, in which the position of conservatively-minded painters is reflected. On the initiative of Franz Marc, Piper Verlag publishing house responds with the anthology *Im Kampf um die Kunst (In the Struggle for Art)*, in which — besides Marc and Kandinsky — many painters, writers and theoreticians come forward with their opinions. In this same year (1911), Piper Verlag also publishes Kandinsky's first important written work, *Über das Geistige in der Kunst (Concerning the Spiritual in Art)*.

Page 146, above:
Kandinsky during his studies in Moscow, ca 1888.

Page 146, below:
Kandinsky with his students in Kochel, 1902.

Page 147:
Portrait of Kandinsky, ca 1913. Photography published in his book *In Struggle for Art (Rückblike)* in 1913.

Kandinsky had met Marc in 1910. Soon thereafter they conceive the Blaue Reiter (Blue Rider) project. The publication by Piper Verlag in May 1912 of the *Blaue Reiter Almanach (Blue Rider Almanac)* becomes an epoch-making event. The anthology not only includes reproductions of works by the group's members, but essays on contemporary music by the composers Arnold Schoenberg, Alban Berg and Anton von Webern. Kandinsky contributes articles and the theater piece *Der gelbe Klang (The Yellow Sound)* to the book. Although the Blaue Reiter exhibitions draw a great deal of attention, Kandinsky soon leaves the group.

In October 1912 his first one-man exhibition takes place in Herwarth Walden's Der Sturm gallery, in Berlin. Kandinsky also participates in a number of other exhibitions, including ones in Russia.

In 1913 several of his works are exhibited for the first time in New York. There he receives a commission to paint four large panels for the entrance hall of a private home. In 1914 one-man exhibitions open at the Thannhauser Gallery, and at Kreis für Kunst gallery in Cologne.

With the outbreak of the First World War, Kandinsky and Münter escape to Zurich, whence Kandinsky sets off for Russia by himself. The couple's last meeting, in Stockholm during the winter of 1915-1916, marks the end of their relationship.

In 1917 he marries Nina Andreevskaya, the daughter of a Russian Army captain. After the October Revolution Kandinsky holds a number of different positions in the newly created Soviet cultural institutions. He is among the founders of INKHUK (Institute of Artistic Culture) and heads its monumental painting studio.

In 1920 fifty-four of his works are exhibited in Moscow at the 19th Exhibition of the Russian Central Exhibition Committee. But Kandinsky finds himself increasingly in conflict with others, especially with his INKHUK colleague Alexander Rodchenko.

In December 1921 Kandinsky leaves the Soviet Union and returns to Germany. At first he stops in Berlin, where he finds himself alone. Many of his friends, Franz Marc and August Macke among

Page 148 :

Kandinsky in front of *Small Pleasures*, June 1913.

Page 149 :

Nina von Andreewsky before her marriage with Kandinsky, 1913–1914, Musée national d'art moderne, Centre Georges Pompidou, Paris.

them, had perished in the war. Therefore he gladly accepts an invitation from Walter Gropius to work at the recently opened Bauhaus school in Weimar. Kandinsky heads the mural painting studio. At the Bauhaus he not only employs the course of study he had developed in Moscow for INKHUK, but draws on the latest findings of Gestalt psychology. His teachings on light are an elaboration of work he had begun earlier. The analysis of forms he makes use of in his teaching is, however, wholly new. In 1926 this analysis is published in Munich under the title *Punkt und Linie zu Fläche (Point and Line to Plane)*.

In 1923 Kandinsky has his first one-man exhibition in New York. In 1924, together with his Bauhaus colleagues Paul Klee, Lyonel Feininger and Alexei Jawlensky, he organizes the *Blue Four* group, whose lectures and exhibitions reach the United States.

In 1925 the Bauhaus is moved to Dessau. In honor of Kandinsky's sixtieth birthday the first number of the journal *Bauhaus*, dedicated to the artist, is published. Retrospective exhibitions are held in many cities. From 1927 on, he leads the painting class at Bauhaus.

In 1928 his production of Mussorgsky's *Pictures at an Exhibition* is performed at the Friedrich Theater in Dessau. In this same year Gropius leaves the Bauhaus. Under his successors, Kandinsky gradually withdraws from teaching. The Nazi seizure of power in 1933 is the final straw: Kandinsky emigrates to France. During the course of the "Degenerate Art" campaign in 1937, many of his works are confiscated from German museums or destroyed.

In Paris, Kandinsky is unable to achieve his previous standing. But, as a world-famous artist, he exhibits: at the Galerie de Cahiers d'Art (1934), at the exhibitions "Abstract and Concrete" (London, 1936) and " Cubism and Abstract Art" (New York, 1936), and at the Stedelijk Museum (Amsterdam, 1938). In 1944 he attends his own exhibition at Galerie l'Esquisse in Paris. He dies in Neuilly-sur-Seine on December 13, 1944.

Page 150 :

Kandinsky and Gabriele Münter in Stockholm, 1916. Gabriele Münter and Johannes Eichner-Stiftung, Munich.

Page 151 :

Kandinsky in his office in Ainmillerstraße in Munich, 1913. Photography by Gabriele Münter. Gabriele Münter and Johannes Eichner-Stiftung, Munich.

Page 152:

Kandinsky in his study in Neuilly-sur-Seine, 1936. Photograph: Musée national d'art moderne, Centre Georges Pompidou, Paris.

Page 153:

Vasily and Nina Kandinsky in their dining room in Dessau, 1926.

Captions

Page 6:
Exotic Birds,
Tretyakow Gallery, Moscow.

Page 8:
Gouspiar,
Tretyakow Gallery, Moscow.

Page 9:
Prayer.

Page 10:
The Port of Odessa, late 1890s.
Oil on canvas, 65 x 45 cm,
Tretyakow Gallery, Moscow.

Page 12:
Landscape Near Achtyrka,
Tretyakow Gallery, Moscow.

Page 13:
Achtyrka. Autumn, sketch, 1901.
Oil on canvasboard, 23.7 x 32.7 cm,
Municipal Gallery of Lenbachhaus,
Munich.

Page 14:
Munich. Schwabing, 1901.
Oil on cardboard, 17 x 26.3 cm,
Tretyakow Gallery, Moscow.

Page 15:
Red Church, 1901.
Russian Museum, St Petersburg.

Page 16:
Mountain Lake, 1899.
Oil on canvas, 50 x 70,
Manukhina Collection, Moscow.

Page 17:
Summer River

Page 19:
Farewell (large version), 1903.
Oil on panel, (two blocks),
31.2 x 31.2 cm,
Tretyakow Gallery, Moscow.

Page 20:
*Kochel (The Lake and the Hotel
Grauer Bär)*, ca 1902.
Oil on cardboard, 23.8 x 32.9 cm,
Tretyakow Gallery, Moscow.

Page 21:
Autumn River,
Russian Museum, St Petersburg.

Page 22:
Poster for the first "Phalanx" Art
School exhibition, 1901.
Color lithograph (after Kandinsky's
drawing), 47.3 x 60.3 cm,
Municipal Gallery of Lenbachhaus,
Munich.

Page 23:
Veil of Gold, 1903.
Tretyakow Gallery, Moscow.

Page 24:
Holland, Beach Chairs, 1904.
Oil on canvas, 24 x 32.8 cm,
Städtische Galerie im Lenbachhaus,
Munich.

Page 25:
Spring,
Russian Museum, St Petersburg.

Page 26:
Church in Murnau I, 1910.
Oil and watercolour on cardboard,
Municipal Gallery of Lenbachhaus,
Munich.

Page 27:
Church in Murnau, 1908-1909.
Oil and tempera on cardboard,
Museum of Fine Arts, Omsk.

Page 28:
The Park of Saint Cloud,
Color Xylograph, 18.9 x 23.9 cm,
Private Collection, Moscow.

Page 30:
Street in Murnau, 1908.
Oil on cardboard, 33 x 44.3 cm,
Tretyakow Gallery, Moscow.

Page 31:
Summer Landscape, 1909.
Oil on cardboard, 34 x 45 cm,
Russian Museum, St Petersburg.

Page 33:
*Murnau. Landscape with Green
House*, sketch, 1908.
Oil on cardcoard, 33 x 44 cm,
Hermitage, St Petersburg.

Page 34:
*Landscape Near Murnau with
Locomotive*, 1909.
Oil on cardboard, 26 x 49 cm,
Municipal Gallery of Lenbachhaus,
Munich.

Page 35 :
Street in Sun of Fall, Oil on canvas.

Page 36:
Mirror, 1907.
Municipal Gallery of Lenbachhaus,
Munich.

Page 37:
Boat Trip, 1910.
Oil on canvas, 98 x 105 cm,
Tretyakow Gallery, Moscow.

Page 38:
The Blue Mountain, 1908-1909.
Oil on canvas, 106 x 96.6 cm,
Guggenheim Museum, New York.

Page 40:
Winter Landscape I, 1909.
Oil on cardboard, 75.5 X 97.5 cm,
Hermitage, St Petersburg.

Captions

Page 76:
Composition E.

Page 77:
Composition III.

Pages 79:
Composition VII, 1913.
Oil on canvas, 200 x 300 cm,
Tretyakow Gallery, Moscow.

Page 80:
Harbour, 1916.
Oil on foil, glass, 21.5 x 26.5 cm,
Tretyakow Gallery, Moscow.

Page 81:
Untitled, 1916.
Oil on canvas, 50 x 66 cm,
Museum of Fine Arts, Krasnodar.

Page 82:
Winter Day. Smolenski Boulevard, ca
1916.
Oil on canvas, 26.8 x 33 cm,
Tretyakow Gallery, Moscow.

Page 83:
Twilight, 1917.
Oil on canvas, 91.5 x 69.5 cm,
Russian Museum, St Petersburg.

Page 84:
Suburbs of Moscow,
Oil on canvas mounted on cardboard,
26.2 x 25.2 cm,
Tretyakow Gallery, Moscow.

Page 85:
Moscow, Zubovsky Square, ca 1916.
Oil on cardboard, 34.4 x 37.7 cm,
Tretyakow Gallery, Moscow.

Page 86:
Blue Comb, 1917.

Page 87:
Grey Oval, 1917.
Oil on canvas, 104 x 134 cm,
Picture Gallery, Ekaterinburg.

Pages 89:
Moscow, Red Square, 1916.
Oil on canvas, 51.5 x 49.5 cm,
Tretyakow Gallery, Moscow.

Page 90:
Southern, 1917.
Oil on canvas, 72 x 101 cm,
Art Gallery, Astrakhan.

Page 91:
Moroseness, 1917.
Oil on canvas, 105 x 134 cm,
Tretyakow Gallery, Moscow.

Page 92:
Picture with Points, 1918.
Oil on canvas,
Russian Museum, St Petersburg.

Page 93:
Composition on Brown, 1919.
Watercolor, India ink, pen and white
on paper,
Pushkin Museum of Fine Arts,
Moscow.

Page 94:
Amazon, 1918.
Glass-painting, 32 x 25 cm,
Russian Museum, St Petersburg.

Page 95:
Rose Knight, 1918.
Glass-painting,
Russian Museum, St Petersburg.

Page 97:
White Oval, 1919.
Oil on canvas, 80 x 93 cm,
Tretyakow Gallery, Moscow.0:
Composition. Colors,
Tretyakow Gallery, Moscow.

Page 98:
Amazon, 1917.
Oil on canvas, 80 x 93,
Tretyakow Gallery, Moscow.

Page 99:
Amazon in the Mountains, 1918.
Glass-painting, 32 x 25 cm,
Russian Museum, St Petersburg.

Page 100:
Two Ovals, 1919.
Oil on canvas, 107 x 89.5 cm,
Russian Museum, St Petersburg.

Page 102:
Musical Opening. Violet Arrow, 1919.
Oil on canvas, 60 x 67 cm,
Museum of Fine Arts, Toula.

Pages 103:
Composition. Red and Black, 1920.
Oil on canvas, 96 x 106 cm,
Museum of Fine Arts, Uzbekistan.

Page 104:
On White, 1920.
Oil on canvas, 95 x 138 cm,
Russian Museum, St Petersburg.

Page 105:
On Yellow, 1920.
Oil on canvas,
Museum of Fine Arts, Uzbekistan.

Page 107:
Red Oval, 1920.
71.5 x 71.2 cm,
Guggenheim Museum, New York.

Page 108:
Untitled, 1920-1921.
India ink and watercolour on paper,
Tretyakow Gallery, Moscow.

Page 109:
Small Worlds V, 1922.
Color lithograph, 36 x 28 cm,
Städtische Galerie im Lenbachhaus,
Munich.

Page 110:
Blue Circle, 1922.
Oil on canvas, 110 x 100 cm,
Guggenheim Museum, New York.

Page 111:
In a Black Square, 1923.
Oil on canvas, 97.5 x 98 cm,
Guggenheim Museum, New York.

Pages 112:
Different Parts, 1940.
Oil on canvas, 89.2 x 116.3 cm,
Gabriele Münter and Johannes
Eichner-Stiftung, Munich.

Page 114:
Decisive Pink, 1932.
Oil on canvas, 80.9 x 100 cm,
Guggenheim Museum, New York.

Page 115:
Several Circles, 1926.
Oil on canvas, 140.3 x 140.7 cm,
Guggenheim Museum, New York.

Page 116:
Scala.

Page 117:
Abstractions,
Engraving,
Tretyakow Gallery, Moscow.

Page 118:
Varied Actions, 1941.
Oil on canvas, 89.2 x 116.1 cm,
Guggenheim Museum, New York.

Page 120:
Engraving III, 1918.
13.5 x 16 cm,
Tretyakow Gallery, Moscow.

Page 121:
Composition. Untitled.
Tretyakow Gallery, Moscow.

Pages 122:
Composition,
Private Collection.

Page 124:
Composition. Color and Ligne.

Page 125:
Engraving IV, 1916.
39.9 x 29.8 cm,
Tretyakow Gallery, Moscow.

Page 126:
Abstract Composition,
Tretyakow Gallery, Moscow.

Page 127:
Composition. Lines and Colors.

Page 128:
Blue Heaven, 1940.
Oil on canvas, 100 x 73 cm,
Museum of Modern Art, Centre
Georges Pompidou, Paris.

Page 130:
Stencil Painting with Rider, ca 1910.
Oil and pencil on cardboard,
24.2 x 33 cm.

Page 131:
Untitled, 1915.
Pen and india ink on paper,
Museum of Fine Arts, Krasnodar.

Page 133:
Floors, 1929.
Oil on canvas, 56.6 x 40.6 cm.

Pages 134:
Aquarelle,
Tretyakow Gallery, Moscow.

Page 135:
Silhouette of a Woman.

Page 136:
Observations about the Theory of
Colors and sketches, ca 1930.
27.5 x 21.1 cm.

Page 138:
Cup with Saucer, ca 1920.
Painted by Kandinsky,
State Porcelain Factory, St Petersburg,
Private Collection.

Page 140:
Chair, ca 1910.
Decorated by Kandinsky,
85 x 41 x 37.5 cm.

Page 141:
Writing-table, ca 1910.
Decorated by Kandinsky,
80 x 89.2 x 60 cm.

Page142:
Dish painted by Kandinsky.

Page 143:
Dish painted by Kandinsky.

Page 145:
Composition. Untitled.
Tretyakow Gallery, Moscow.

Index of Works